Stories in Stone

Introduction and Overview

The Portraits and the Players

1 **Clara Irwin** (1815-1911), wife of businessman Robert Irwin who owned the home now known as the Elijah Iles House, portrayed by *Mary Disseler.*

2 **Leanna Donnegan Knox** (1797-1876), a free woman of color whose son William Donnegan was murdered during the 1908 Race Riots, portrayed by *Connie McGee.*

3 **John Williams** (1808-1880), a founder of the First National Bank of Springfield and namesake of Williamsville and Williams Boulevard in Springfield, portrayed by *Donn Stephens.*

4 **Reverend Francis Springer** (1810-1892), founder of the first Lutheran worship services in Springfield, who was instrumental in establishing the Home for the Friendless in Springfield, portrayed by *William Furry.*

5 **Rosa Kun Keydell** (1827-1911), wife of Andrew Kun, who operated Kun Brewery beginning in 1856. After his death Rosa married Robert Rudolph, then Moritz Keydell, both of whom continued operating the brewery, portrayed by *Tracy Petro.*

6 **Mattie Lightfoot** (1857-1920) At seven years old she and three siblings along with a boatload of other civil war orphans were transported from Arkansas to Springfield, portrayed by *Deborah Brothers.*

7 **Henry Owsley** (1755-1811), a Revolutionary War veteran who owned a large plantation in Kentucky, portrayed by *Keith Wilson.*

8 **Moses Broadwell** (1764-1827), a Revolutionary War veteran who settled in Sangamon County near Pleasant Plains in 1820. He and his son John built Broadwell Inn, portrayed by *Jerry Smith.*

"As you walk back to your car, we are sure that you will feel a little sad and reluctant at parting with the grand company of souls you have met here. We hope that you will have been inspired by the notable heritage represented here and that you will return to Oak Ridge again another day."

from A Walk Through Oak Ridge Cemetery, by Dr. Floyd Barringer

The Sangamon County Historical Society wishes to thank the following for their support of the Cemetery Walk

Oak Ridge Cemetery Board of Managers
Mike Lelys, Executive Director, Oak Ridge Cemetery
Butler Funeral Homes
Staab Funeral Home
Lincoln Monument Association
Oak Ridge Cemetery Foundation
African American History Museum

This year's walk would not have been possible without the assistance of the following volunteers

Chairman: Mary Alice Davis
Communications: Ernie Slottag
Logistics: Larry Stone
Parking: Judith Barringer, Doug Barringer
Publicity: Ruth Slottag, Susan Helm
Re-enactors: Linda Schneider
Sites: Curtis Mann
Scripts and Sangamon Links Editor: Mike Kienzler
Treasurer: Jerry Smith
Volunteers: Jennie Battles

Sandy Bellatti
Mary Barringer
Pat Baska
Roni Betts
Sally Cadagin
Pamm Collebrusco
Marge Deffenbaugh
Kathy Dehen
Laura Demick
Claire Eberle

Elaine Hoff
Sue Massie
Doug Polite
Marlene Rinehart
Mary Schaefer
Kay Smith
Deb Stahl
Gene Walker
Angie and Duane Weiss
Vicky Whitaker

Sangamon County Historical Society

P.O. Box 9744 • Springfield, IL 62791-9744
217-525-1961 • www.sangamonhistory.org • schsoffice@gmail.com

Echoes of Yesteryear: A Walk Through Oak Ridge Cemetery

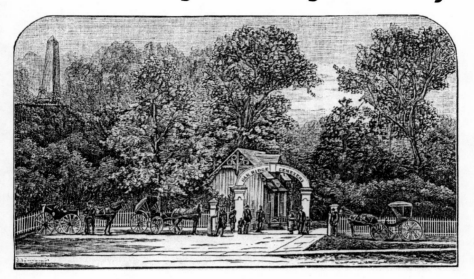

Sunday, October 9, 2016
12 Noon - 4 pm (last start at 3:15 pm)

Welcome to the 13th "Walk Through Oak Ridge Cemetery." We invite you to begin your tour at the cemetery's bell tower.

Actors and actresses dressed in period costumes will portray eight historical individuals who have been buried at Oak Ridge over the years.

Please see the map on the following page to locate each gravesite and the bus stops, which will take you up and down the hill.

Also, take time to enjoy a display of the re-creation of the Lincoln funeral hearse, musical entertainment by the Prairie Aires, concessions and sales of Sangamon County Historical Society publications all located near the bell tower.

Donations are suggested. Proceeds will benefit the programs and activities of the Sangamon County Historical Society.

Sponsored by the Sangamon County Historical Society in cooperation with Oak Ridge Cemetery

Oak Ridge Cemetery Map

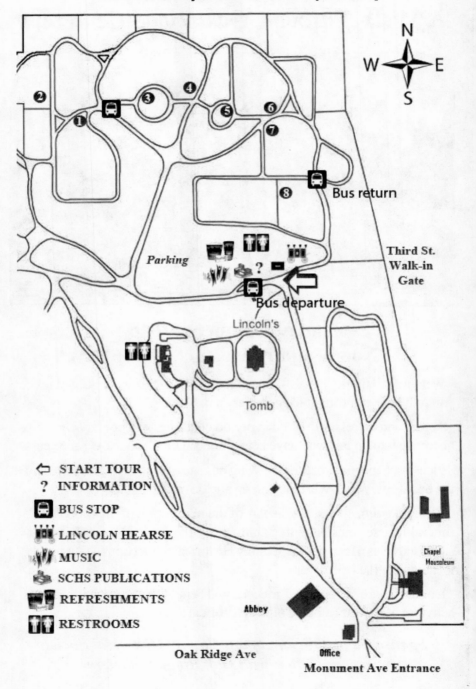

IMAGES
of America

OAK RIDGE CEMETERY

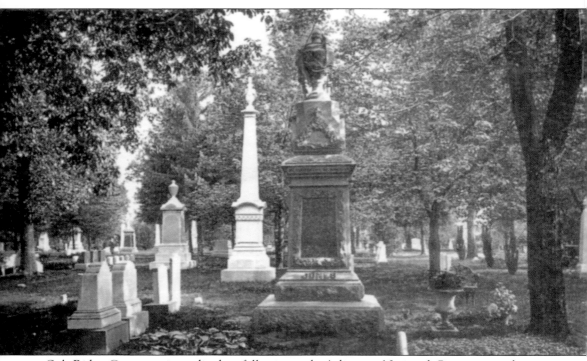

Oak Ridge Cemetery is credited as following only Arlington National Cemetery as the most visited cemetery in the United States. Tens of thousands of visitors, who come to see the burial place of Abraham Lincoln at Oak Ridge, are struck by the great beauty of the cemetery's parklike landscape. This 1889 view shows a few of Oak Ridge's more elaborate monuments.

IMAGES
of America

OAK RIDGE CEMETERY

Edward J. Russo and Curtis R. Mann
Introduction by Mayor Tim Davlin

ARCADIA
PUBLISHING

Published by Arcadia Publishing
Charleston, South Carolina

Printed in the United States of America

Library of Congress Control Number: 2009929202

For all general information contact Arcadia Publishing at:
Telephone 843-853-2070
Fax 843-853-0044
E-mail sales@arcadiapublishing.com
For customer service and orders:
Toll-Free 1-888-313-2665

Visit us on the Internet at www.arcadiapublishing.com

*This book is dedicated to all those who have cared for
Oak Ridge through the years—staff, management, board members,
and others. These individuals have unobtrusively watched
over the cemetery's grounds, kept its records, and preserved for us
a place of quiet beauty and meditation for a century and one half.*

CONTENTS

ACKNOWLEDGMENTS

This history of Oak Ridge Cemetery is possible only because of the dedicated research of earlier historians. Notable among these is Dr. Floyd Barringer, whose *A Walk Through Oak Ridge Cemetery* (1967) remains a popular tour guide to the cemetery. We are also indebted to early historians and record keepers, especially Lincoln Monument custodian and Springfield historian John Carroll Power, who compiled a detailed history of the monument and attempt to steal Abraham Lincoln's body. George Cashman's historical articles were helpful, as were the reports by Dr. Henry Wohlgemuth, longtime Oak Ridge board president, responsible for overseeing the cemetery's early landscape development. Wohlgemuth also carefully collected Oak Ridge history and that of previous city graveyards. We deeply appreciate the work of numerous photographers who recorded the beauty of Oak Ridge for 150 years. We are grateful for the generous assistance of LuAnn Johnson, director of Oak Ridge Cemetery, and Arcadia Publishing's Jeff Ruetsche for shepherding this project to completion.

Unless otherwise noted, all images appear courtesy of the Sangamon Valley Collection at Lincoln Library, Springfield's public library.

INTRODUCTION

When I was a child, I remember Oak Ridge as a huge expanse of green lawns and hills with some of the biggest trees I had ever seen. Oak Ridge for me was the place where in the spring we would gather for the annual Boy Scout pilgrimage. Starting at the Lincoln Tomb, a tsunami of boys with bright blue shirts and even brighter yellow kerchiefs would order ourselves into neat waves and make the trek to the old state capitol. You would never really know how hot the day would get until you left the cooling shade of all those white oaks and maples.

As I grew older, I became aware of the rich history of the cemetery beyond being the resting place of our 16th president. Governors, legislators, socialites, poets, soldier-heroes, movers, and shakers in Illinois history can be found resting there. If you know where to look, you can learn about the high points as well as the low points in Springfield history. Evidence is there, too, of the ravages of the 1918 Spanish influenza pandemic and of the fragile childhoods in a world with few vaccines and no antibiotics.

There we find monuments to those who gave their lives so that our liberties would remain strong—and there we come together to share a sense of the sacred. From simple grave markers to the more ornate, the cemetery reflects every American architectural style from 1860 to the present.

One of my first forays into life as a public servant came with my appointment to the Oak Ridge Cemetery Board over 20 years ago. That is when I learned about the operational side of the cemetery—what it takes to manage the 365-acre place that is the second-most-visited cemetery in the nation. The pervasive sense of tranquility and serenity associated with the cemetery comes from its underlying design but also from the hard work and unrelenting attention to detail by the small but dedicated staff. What draws people to the cemetery—even those who do not come to remember their own loved ones—is the eloquence of those stones, under the stillness of those trees. Oak Ridge as an institution remembers what it means to remember.

Few individuals are better positioned to explore the richness of Oak Ridge than the former City of Springfield historian Edward Russo and the present city historian, Curtis Mann. In this book, they describe how the cemetery got its name; how it was designed; how its governance as well as its acreage evolved; how it was an exemplar of a new generation of the parklike, carefully tended, landscaped cemeteries we take for granted today; and, of course, who are the notables resting there.

There is no better place to ponder that last syllable of recorded time than at Oak Ridge—and no better guides than Russo and Mann.

—Tim Davlin, mayor of Springfield, Illinois

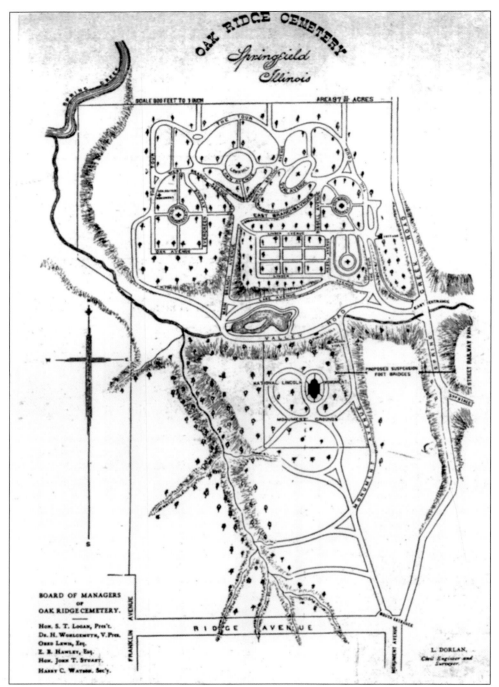

This 1872 map was prepared by city engineer Louis Dorlan. It is the earliest-known plan of the cemetery, which was designed by William Saunders in the 1860s. Because none of Saunders's Oak Ridge drawings are known to exist, it is assumed that this map documents the designer's original plans. The curving drives and naturalistic plantings are characteristic of the new rural landscape cemetery movement.

One

OAK RIDGE EARLY DAYS

Oak Ridge Cemetery is second only to Washington, D.C.'s Arlington National Cemetery in the number of annual visitors. Most people come to see Abraham Lincoln's tomb, of course, but most are also taken with the great beauty of the surrounding cemetery. Victorians created these parklike cemeteries as a way to deal with the grief of death that came often in those years, especially among children. Historian Gary Wills has identified the late 19th century's "culture of death" in every aspect of life. Wills points to Abraham Lincoln's famed Gettysburg Address as "part of the 19th century's fascination with death in general and with cemeteries in particular." This obsession produced one of America's greatest contributions to landscape architecture—the rural landscape cemetery. Springfield's Oak Ridge Cemetery is a prime example of that new type. Out of these romantic landscapes came the spark of the American park movement in U.S. cities.

Known as rural cemeteries for their locations outside town, they signaled a radical change in attitudes about death, which now came to be seen as a means of reunion with loved ones and with God. These new rural burial places were also an obvious answer to overcrowded city graveyards hemmed in by development. The earliest example was Pere La Chaise Cemetery of 1815 near Paris. It delighted visitors with curving drives and naturalistic groves of trees mimicking an untouched wilderness. American versions followed, with more than a dozen appearing between 1830 and 1860. Springfield's Oak Ridge was an important example among them.

By 1855, city growth had encircled Springfield's private Hutchinson Cemetery and publicly owned city graveyard. In June of that year, the city council purchased seven wooded, rolling acres north of the city. The new cemetery board eventually engaged leading landscape designer William Saunders to create a design of winding drives and naturalistic plantings to complement the hilly terrain and groves of oak trees. Saunders's design work and more than 150 years of sensitive care and additions have resulted in a parklike oasis enjoyed today by hundreds of thousands of visitors and locals. The following pages tell the story of the cemetery's birth and early years.

Springfield founder Elijah Iles was also one of the city's most active promoters. Iles owned the first store and was primarily responsible for securing the county seat for Springfield. He also donated land for several institutions, including the city graveyard in 1836. By his death in 1883, his graveyard had become obsolete and most bodies had been moved to the new, rural Oak Ridge Cemetery.

This section of an 1855 map of Springfield shows the two original city cemeteries, Hutchinson at center left and the city graveyard to its right. Both were located in the rolling terrain along Adams Street, west of First Street. By the time this map was printed, the Springfield City Council was already planning for a new city cemetery north of town.

Undertaker was a new job title from the 19th century. In an era of increasing specialization, trades and professions began taking responsibility for work once performed at home. Burial was no exception. Cabinetmakers began by providing caskets, at first building wooden ones and then acting as agents for manufactured ones. John Hutchinson was one of Springfield's first cabinetmakers to follow this new career. His 1860 advertisement offers everything from the most ordinary to "the elegant Metalic [sic] Burial Case."

John Hutchinson supplemented his cabinetmaking income by opening a private burial ground—Hutchinson Cemetery. His young apprentice, Thomas C. Smith, eventually purchased the business and cemetery. In those years people lived as close to their work as possible. Smith's modest house, in the 300 block of West Adams Street, was close to Hutchinson Cemetery and across from the city graveyard. It was demolished in the 1990s.

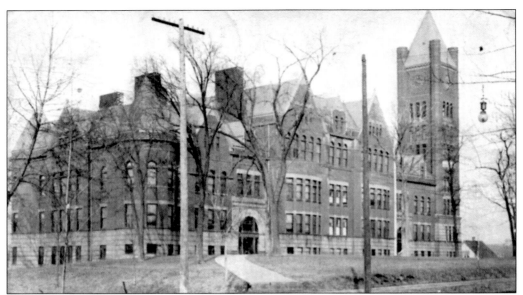

With the closing of the former Hutchinson and city cemeteries, and removal of graves to Oak Ridge, the land remained unoccupied. The Springfield School District changed that when it located a new high school (above) on the grounds of the old city graveyard in 1897. About 1909, the Springfield Park District opened Forest Park at the former Hutchinson Cemetery. Despite a tennis court and cheerful flower plantings, the public still avoided the place because of its association as a graveyard. In 1917, a still newer Springfield High School (below) replaced Hutchinson/Forest Park. Seventy-one giant oaks and maples, some over 200 years old, were felled during construction. The 1897 school building, renamed Central, became a junior high school and was later used for school board offices until its demolition in 1961.

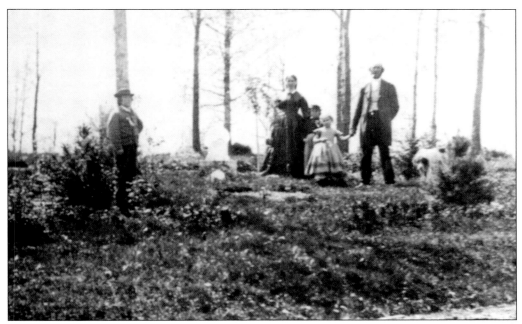

After Oak Ridge opened in 1855, city engineer William Sides designed the original grounds "in squares, regardless of natural slopes and ravines, or of the general character of the ground." But that changed under George Willis, appointed sexton in 1858 and shown above with his family at Oak Ridge. Willis, formerly with Long Island's celebrated Green Wood Cemetery, was knowledgeable about new rural cemetery fashion. Possibly he suggested designer William Saunders, who was engaged by the board of managers to develop a landscape plan for Oak Ridge. Until 1900 the main entrance and office were on Third Street (below), set amid the thick grove of oak trees that gave the cemetery its name. Only a few streets of the original grid plan remain today, lost amid the curving roads.

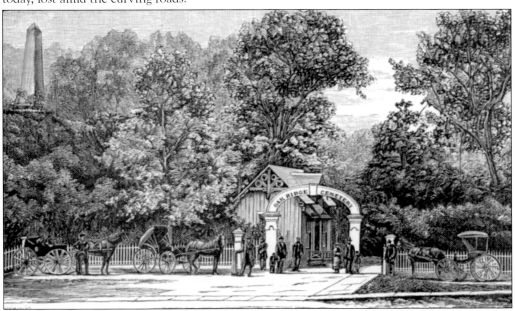

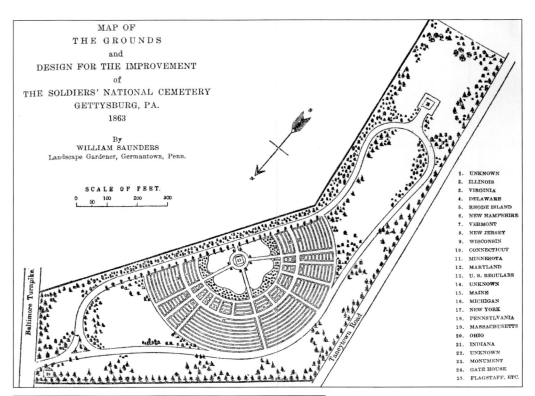

MAP OF
THE GROUNDS
and
DESIGN FOR THE IMPROVEMENT
of
THE SOLDIERS' NATIONAL CEMETERY
GETTYSBURG, PA.
1863

By
WILLIAM SAUNDERS
Landscape Gardener, Germantown, Penn.

SCALE OF FEET.
0 50 100 200 300

Baltimore Turnpike

Taneytown Road

1. UNKNOWN
2. ILLINOIS
3. VIRGINIA
4. DELAWARE
5. RHODE ISLAND
6. NEW HAMPSHIRE
7. VERMONT
8. NEW JERSEY
9. WISCONSIN
10. CONNECTICUT
11. MINNESOTA
12. MARYLAND
13. U. S. REGULARS
14. UNKNOWN
15. MAINE
16. MICHIGAN
17. NEW YORK
18. PENNSYLVANIA
19. MASSACHUSETTS
20. OHIO
21. INDIANA
22. UNKNOWN
23. MONUMENT
24. GATE HOUSE
25. FLAGSTAFF, ETC.

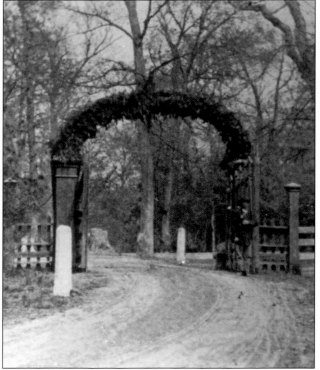

William Saunders was hired by the Oak Ridge Board of Managers to lay out the new cemetery. Despite the ground's natural beauty, little had been done to take advantage of the site. The Scots-born Saunders trained at London's famous Kew Gardens. In America he became head of Johns Hopkins's Baltimore estate. Hired by the United States Department of Agriculture, he designed the cemetery at Gettysburg (above) and laid out the park system of Washington, D.C. An influential landscape writer, Saunders tirelessly advocated for a natural look in parks, gardens, and cemeteries. Even the Third Street entrance gate (left) was "naturalized" with vines. Locating the main entrance at the lowest point on the grounds gave the surrounding hills an even more impressive appearance.

This 1860s view, facing toward the site where the Lincoln Tomb would be built, shows the heavily wooded character of the original Oak Ridge acreage. Speaking at the May 24, 1860, dedication, ex-mayor James Conkling praised this sylvan beauty and declared that "here with naught but the pure arch of heaven above us, and nature in all her silent beauty and loveliness around us . . . we dedicate the city of the dead."

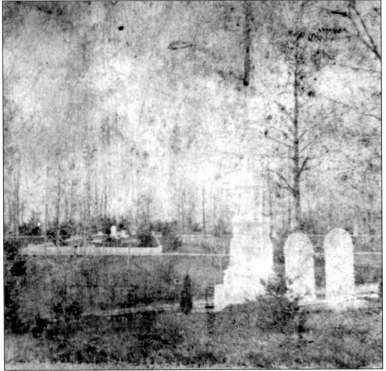

After a few years lots at Oak Ridge sold steadily and families began erecting limestone and granite grave markers. This 1860s view, by landscape photographer Marcel Duboce, presents a melancholy beauty with an already mature landscape softening the glare of new stones. This was originally printed as a stereoscope card, allowing viewers to see it in three dimensions.

15

Obelisk-style grave markers were among the most popular 19th-century style. To suit their newfound wealth the Kun family erected this impressive monument in the 1860s. Andrew Kun had been sent to Springfield as an agent by St. Louis brewer William Lemp. Instead Kun struck out on his own and became a wealthy Springfield brewery owner. In 1993, the caverns used to keep Kun beer cool were discovered under Walnut Street.

Early-19th-century Americans romanticized ancient Greece while identifying with modern Greece's struggle for democracy. Greek Revival influence showed everywhere—in architecture, fashion, literature, and government ideals. Even the new rural burial grounds were called cemeteries, which derived from the Greek *koimeterion* ("sleeping place"). Fittingly, the first monuments in these new cemeteries were Greek-inspired designs of obelisks and urns as seen in this 1860s Oak Ridge scene.

Andrew Jackson Downing, America's first important landscape architect, wrote that "in the absence of great public gardens, such as we must surely one day have in America, our rural cemeteries are doing a great deal to enlarge and educate the popular taste in rural embellishment." But Downing blamed the clutter of grave markers for ruining the natural beauty of rural cemeteries. Early-20th-century landscape designers and tastemakers O. C. Simonds and Wilhelm Miller echoed these sentiments in their writings. Miller, in an influential article, "The Straight-Way to Bad Taste," criticized large monuments as vulgar and showy. But increasingly elaborate monuments and markers fulfilled Americans' desire for individual expression. Several Springfield firms provided monuments for bereaved families. One company, Springfield Marble Works, offered "the latest and best design . . . executed in the neatest manner" in its 1855 advertisement.

Abraham Lincoln is believed to have attended the dedication of Oak Ridge Cemetery in 1860 where he would have heard former mayor James Conkling reflect, "When the fitful dream of life is over . . . when man has run his allotted courses and fulfilled his destiny on the earth, here he may find a resting place." Lincoln's assassination in April 1865 brought him back to rest at Oak Ridge after one of the country's most elaborate funeral processions. The journey began with his body lying in state at the White House on April 19, 1865 (below). "The nation rises up at every stage of his coming," said *Harper's Weekly* of the funeral train's progress, "Cities and states are his pall-bearers, and the cannon speaks the hours with solemn progression. Dead, dead, dead, he yet speaketh."

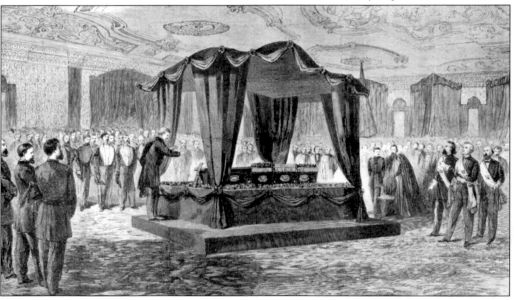

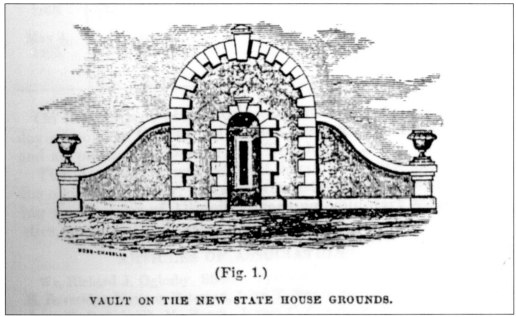

(Fig. 1.)

VAULT ON THE NEW STATE HOUSE GROUNDS.

Immediately after Lincoln's death a group of Springfield businessmen hastily planned to have him buried near downtown Springfield where his mausoleum would become a mecca for mourners and tourists. They arranged for a vault to be erected on the statehouse lawn (above) and received all necessary approvals, except one. They did not count on the bitter opposition of his widow. An incensed Mary Todd Lincoln denounced the plans and let it be known that, unless he were interred at Oak Ridge Cemetery, she would have him buried in Washington, D.C. Local civic leaders quickly arranged to honor her wishes, and Lincoln's body was placed in the cemetery's receiving vault (below) for bodies awaiting permanent burial.

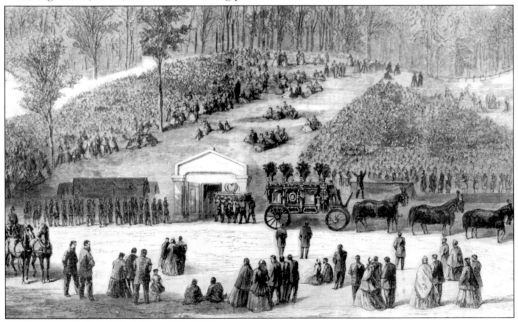

Abraham Lincoln's presidency was filled with conflict and war, and he made bitter enemies. Many people feared that his temporary resting place at Oak Ridge might be vandalized. For a time it was guarded by soldiers (below). In the meantime, construction of a new, temporary vault (left) began. A highly romanticized drawing of that vault appeared on the cover of *Harper's Weekly* in 1868. The artistic rendering of a moody, semi-wild landscape appealed to the Victorians' romanticizing of death—the same impulse that also gave rise to the rural cemetery movement. The new vault was never intended to be permanent, and plans were made to create a monument of which the entire nation could be proud.

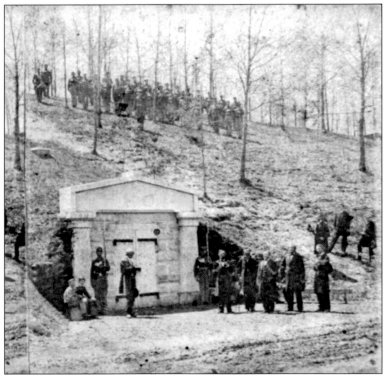

Two

THE LINCOLN MONUMENT

After Abraham Lincoln's death a shocked and mourning nation opened its hearts and wallets to erect a suitable monument in his memory. The Springfield businessmen, who had been thwarted by Mary Todd Lincoln in their attempt to bury her husband near downtown, now turned their attention to erecting a monument in Oak Ridge. They formed the National Lincoln Monument Association and elected Illinois governor Richard Oglesby president. The group was in charge of constructing the temporary vault where the bodies of Abraham Lincoln and his son Willie were placed in December 1865. The association then invited designs for a permanent monument. From 37 submissions they chose Vermont sculptor Larkin G. Mead's proposal for a large obelisk rising 100 feet from a massive base and ornamented with statuary of Lincoln and groupings of infantry, artillery, naval, and cavalry men. Inside the base was a memorial hall. A national fund-raising campaign collected over $170,000, and construction began in 1869. The monument was complete enough by 1871 to accept the body of the Lincolns' son Thomas "Tad," who died that year. A few months later the bodies of Abraham and Willie Lincoln were moved from their temporary vault to the monument.

The monument's granite was quarried in Maine and dressed in Massachusetts before being shipped to Springfield. The statuary, cast in Massachusetts, was modeled by Larkin Mead in Florence, Italy. Funds came from across the country with Chicago, New York, Boston, and Philadelphia citizens paying for the four military groupings. Even though the exterior was not quite complete, a grand dedication ceremony was held on October 15, 1874. On that day, Lincoln's close friend Joshua Fry Speed recalled that "shout after shout rent the air from that vast crowd, but far more touching and tender was it there, among his friends and neighbors, to see tears stream from the eyes of many."

The tomb was rebuilt twice and enlarged, but both times Mead's classic design was retained. Today the Lincoln Monument remains the centerpiece of Oak Ridge and the destination for thousands of visitors annually.

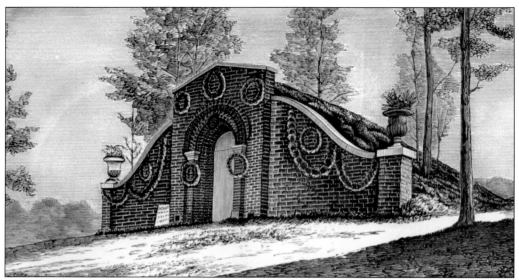

After construction of the new monument, the Lincoln temporary vault (above) was demolished so that it could not be used for any other purpose. While Abraham Lincoln and his son Willie were interred there, construction began on the permanent monument. The City of Springfield donated six acres of land in Oak Ridge to the National Lincoln Monument Association, which contacted landscape architect William Saunders to lay out the monument grounds. Saunders arrived in the city in August 1865 and met with monument association representatives and the Oak Ridge Board of Managers. The Oak Ridge board unanimously voted to accept Saunders's offer to "lay off the entire grounds of the cemetery." Clearing and excavation of the future monument's site is shown below in this 1860s photograph.

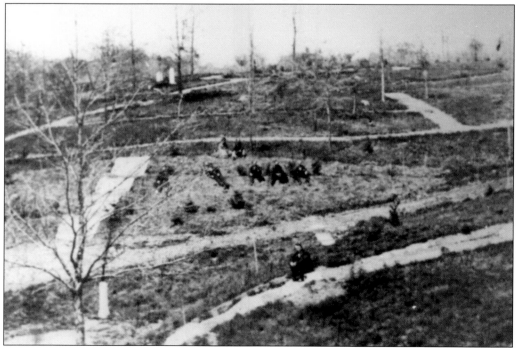

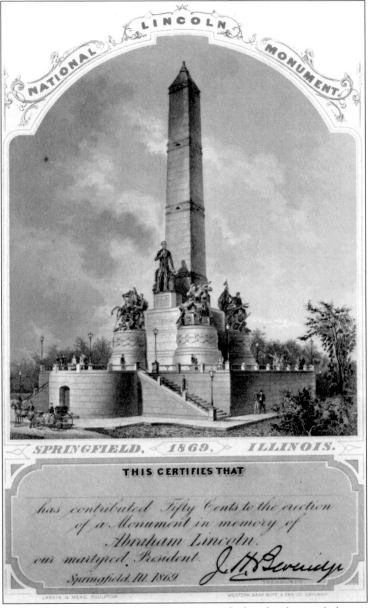

NATIONAL LINCOLN MONUMENT

SPRINGFIELD, 1869. ILLINOIS.

THIS CERTIFIES THAT

has contributed Fifty Cents to the erection
of a Monument in memory of
Abraham Lincoln.
our martyred President.
Springfield, Ill. 1869
J. W. Beveridge
TREASURER.

LARKIN. G. MEAD. SCULPTOR. WESTERN BANK NOTE & ENG CO. CHICAGO.

The National Lincoln Monument Association raised the funds needed to construct the impressive monument and tomb of Abraham Lincoln in Oak Ridge. Contributors who gave 50¢ were issued these certificates, complete with a handsome engraving of the proposed monument, issued by the Western Bank Note and Engraving Company. The association's executive committee, which most directly supervised construction, was made up of "lifelong and intimate friends of Mr. Lincoln." These included John Todd Stuart, John Williams, and Jacob Bunn. For several years the care of the monument was in their hands. But "after a lapse of years in service, most of them have succumbed to the summons of The Great Beyond, and their work ceased." Consequently the remaining members decided to dissolve the organization and convey title of the monument to the State of Illinois in 1898.

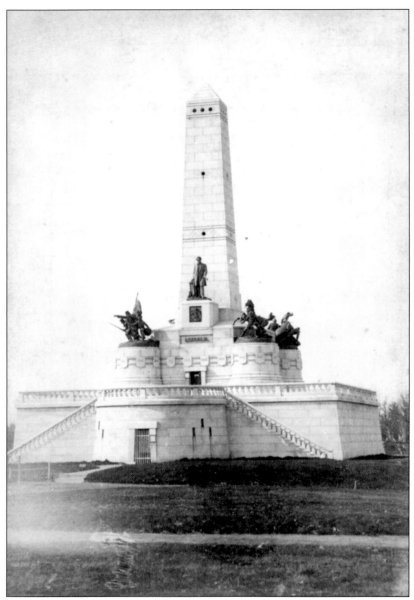

The newly completed monument was a matter of great pride to Springfield generally and to its new custodian John Carroll Powers in particular. Despite it being a national monument, locals felt such a great sense of proprietorship that the National Lincoln Monument Association attempted to prevent anyone from even photographing it without permission. This view, from the 1870s, was copyrighted by custodian Powers and contained a strongly worded warning on the back. "The picture on the other side of this card is secured by copyright. By all of which it will be seen that any person taking or attempting to take pictures of the Monument are amenable under the State laws, and copying the pictures makes him amenable under United States copyright laws." As if realizing that this might seem overly restrictive, they justified their decision by noting that "the Ladies Mount Vernon Association do not permit the taking of pictures at the tomb of Washington, except for their own use, to be kept on sale there."

The heroic scale of monument statuary becomes apparent at close range. Larkin G. Mead's naval group (right) was photographed before it was placed on the monument. Weighing nearly 8,000 pounds, it depicts men on deck poised to shell an enemy. "The boy, whose duty it is to carry cartridges to the piece and who in nautical phrase is called the powder monkey, has elevated himself to the highest position . . . The Commander, however, having taken an observation through his telescope, finds there is no cause to apprehend danger, and is calmly meditating." The statue of Abraham Lincoln (below), removed during a reconstruction, towers over a laborer. The statue was thought very like Lincoln by his friends, down to "the protruding eyebrows, the nose, the mouth with the prominent and slightly drooping lower lip, the mole on his left cheek."

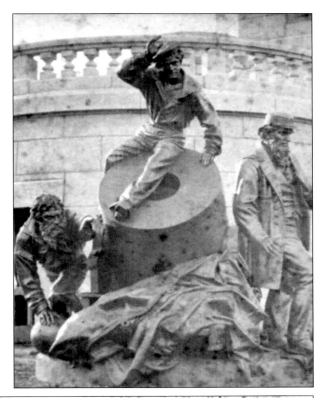

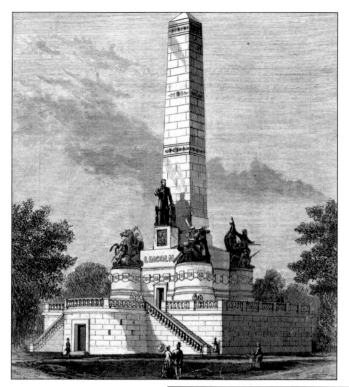

When the Lincoln Monument was dedicated in October 1874, it made news across the country. A *Harper's Weekly* article included an engraving of the structure. Estimated construction costs had risen to $250,000. The memorial hall inside the tomb contained "some interesting relics of the late President" and gave access to the circular iron staircase, which visitors could climb to the top of the obelisk.

Despite restrictions on photographs, several views of the monument appeared in its first decade. This one, made in the 1870s by Springfield photographer Marcel Duboce, shows the front balustrade draped with funerary swags and the statuary groups not yet set in place. "The monument is constructed in the most substantial manner," claimed one reporter. The falseness of this claim was to become sadly apparent in less than a generation.

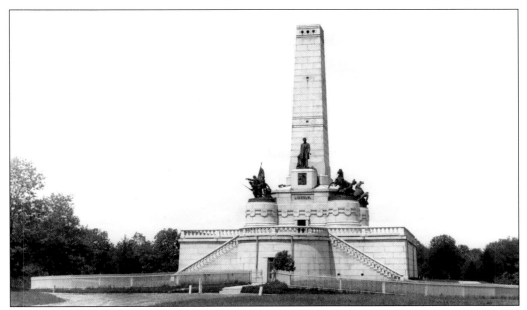

The finished monument is seen here in the early 1890s. A wooden fence gives a curiously domestic appearance to the 20-plus-year-old structure. The general peacefulness of cemetery and tomb was broken by gunfire one night in 1876. Secret service agents and custodian John Carroll Powers foiled an attempt by robbers to steal Abraham Lincoln's body. At a signal they rushed in to find the criminals gone, one agent firing in confusion.

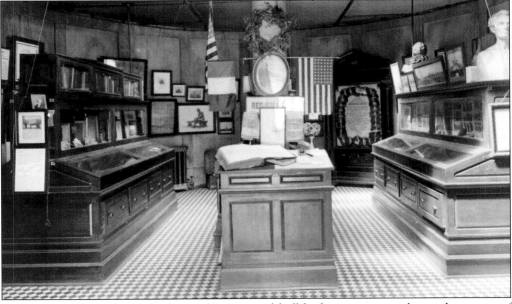

Seen here in the early 1920s, the tomb's memorial hall had grown into a cluttered museum of sorts. Under custodian Herbert Wells Fay, the collection expanded to contain everything from a chair seat repaired by Lincoln to his grandfather's gunpowder horn. Despite complaints from many that this souvenir atmosphere took away from the tomb's dignity, it remained in place for another decade.

When the State of Illinois received title to the property from the National Lincoln Monument Association it became owner of the largest monument in Oak Ridge Cemetery, and one of the more deteriorated. Officials learned that the original six-foot-deep foundation left the structure dangerously weak. Gov. John Tanner requested and received an emergency $100,000 appropriation from the legislature for a complete rebuilding. The bodies of Abraham and Mary Todd Lincoln and their sons Edward, Willie, and Thomas were removed to a temporary location for the two-year project. In 1899, workmen from Springfield's Culver Construction Company began dismantling the entire tomb, which was taken down to its footings (above). New foundations, 23 feet deep, were laid and the obelisk rebuilt in the same style, but nearly 22 feet higher than the original 100 feet (below).

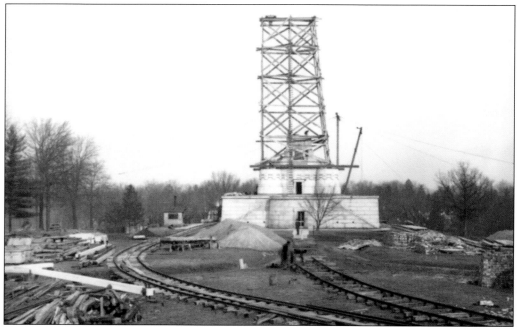

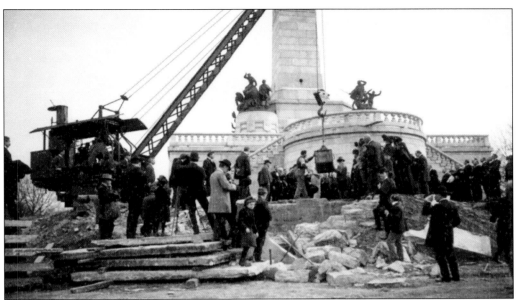

Demolition and reconstruction of the Lincoln Monument was a complex job. The first task for the Culver Construction Company was to carefully inventory and number all stones to be used in rebuilding and then to arrange for their safe storage. But more important was security for the bodies of the Lincoln family, which were secretly buried only a few feet from the reconstruction. With the tomb nearly completed, James Culver supervised his construction crew as they uncovered rubble that had camouflaged the temporary graves. A steam derrick prepares to move the bodies as well-dressed onlookers and officials observe (above). The derrick (below) moves one of the caskets from the temporary vault. According to one account, the setting sun "suddenly colored the scene with a radiance that made people's heart jump . . . throats were choked."

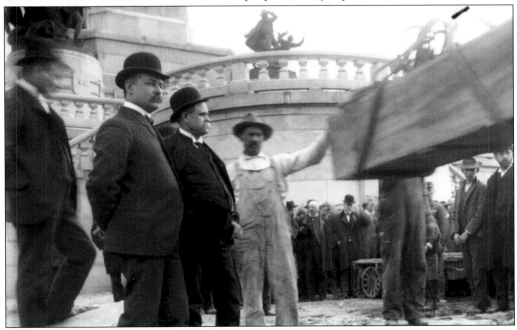

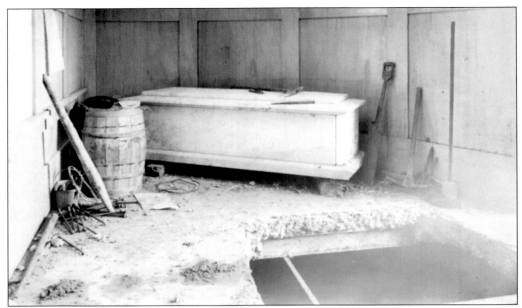

Despite an electric burglar alarm connected from the tomb to the custodian's residence nearby, Robert Todd Lincoln still feared a repeat of the 1876 attempt to steal Abraham Lincoln's body. In 1901, Robert directed the Culver Construction Company to break a hole in the tile floor (above) and place the coffin (protected by a cage of flat steel bars) 10 feet below the floor. Two tons of cement were poured over the coffin, hardening into a massive monolith, where it remains today. James Culver, in bowler hat (below), supervises his crew the day the bodies were moved. In the generation between the Lincoln Tomb's 1874 construction and its 1899 rebuilding, technology had revolutionized stone building work. Massive machinery now moved and placed large stones that had required many hours and several men only a generation earlier.

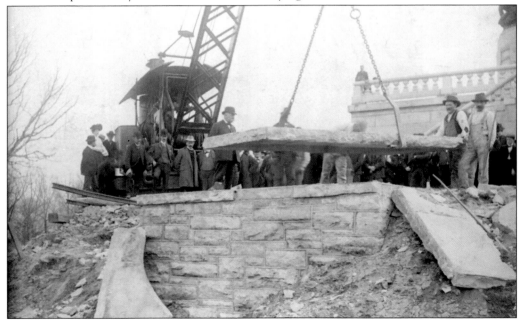

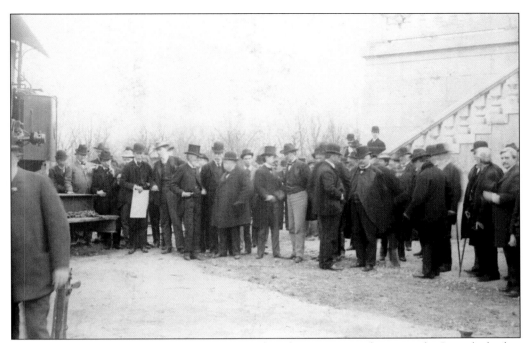

A few hundred well-dressed guests were invited to the ceremony of moving the Lincoln bodies into the completed tomb. These included local dignitaries and many Lincoln friends and acquaintances. Among the guests were five children, including the three boys behind the girl at center in the photograph below. The boys are members of the Keys family, grand-nephews to Mary Todd Lincoln. The woman behind the two boys at left is Josephine Remann Edwards, "who as a girl was the 'little Josie' Lincoln used to carry around on his shoulders on the streets of Springfield." Amid heated debate, officials decided to open the lead-lined casket to be sure that it contained Abraham Lincoln's body. Since his death Lincoln's body had been moved 17 times. People wanted to be certain.

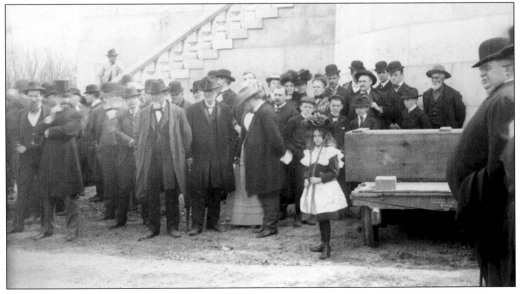

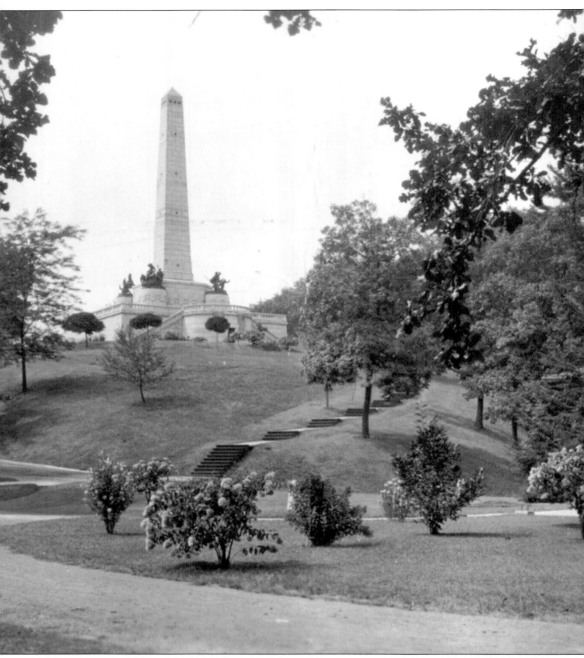

This pastoral 1920s scene shows the rebuilt Lincoln monument and several Oak Ridge buildings added around 1900, now part of the permanent landscape. The towered, ivy-covered building (at right) disguises an efficient office with records protected in a state-of-the-art vault. This panoramic view, taken from the north side of the monument, captures a peaceful summer afternoon amid Oak Ridge's mature trees and manicured lawns. Carefully enforced regulations,

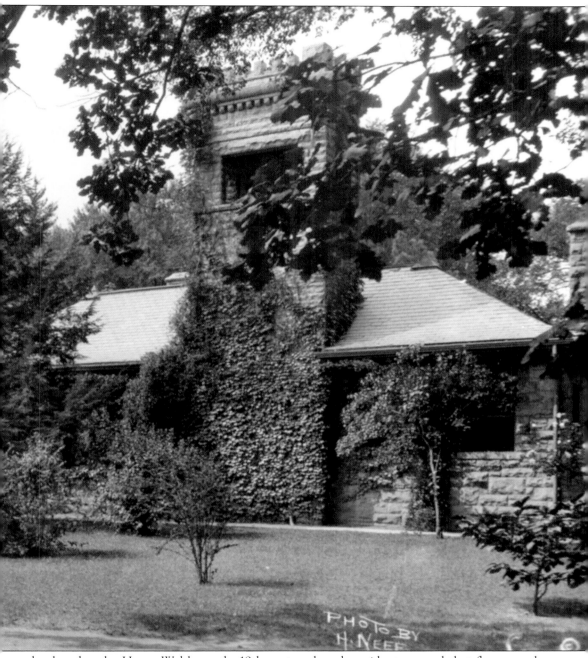

PHOTO BY
H. NEFF

developed under Henry Wohlgemuth, 19th-century board president, assured that flowers and grave plantings were carefully controlled and that the naturalistic plantings of trees and shrubs predominated, contributing to a restful atmosphere. The Lincoln Monument remained the most important structure in the cemetery.

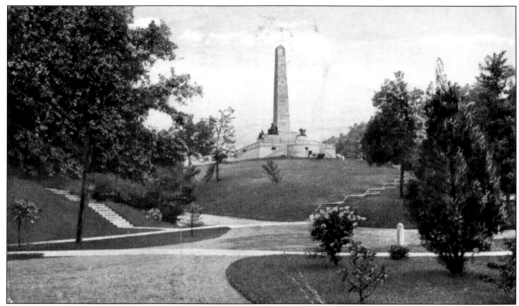

The Lincoln Monument hosted thousands of visitors annually in the first quarter of the 20th century. Its 120-foot-high obelisk towered over the cemetery and appeared in countless books and pamphlets promoting Abraham Lincoln and Oak Ridge Cemetery. The image also appeared on thousands of postcards—that quintessential note back home written by an army of 20th-century tourists (above). School group trips to the tomb also became an annual rite of spring for area schools. Solemn teachers, attempting to hush spring-energized children, explained the significance of the martyred president. A class from Springfield's Enos Elementary School (below) poses at the tomb about 1924. The exterior granite has begun to show discoloration of smoke from coal used to heat houses and power local industry.

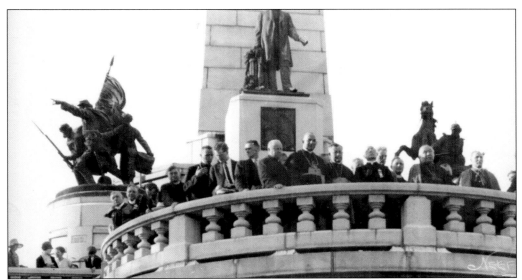

By the 1920s, Abraham Lincoln had become popularly associated with patriotism. The GAR, Sons and Daughters of the American Revolution, and other patriotically inspired groups invoked Lincoln in word and symbol if not always in deed. Reciting of the Gettysburg Address became ritual for schoolchildren, and Lincoln was nearly deified for holding the country together throughout a bloody Civil War. Roman Catholic patriotism was called into question in the 1920s by a revived Ku Klux Klan and even some mainline Protestant leaders. Eager to affirm their love of country and "100 percent Americanism," Catholic leaders often sought approving association with American ideals, including the memory of Lincoln. In these photographs Catholic clergy and laymen visit the tomb, greeted by custodian Herbert Wells Fay, standing at the iron-barred entrance to the tomb (below).

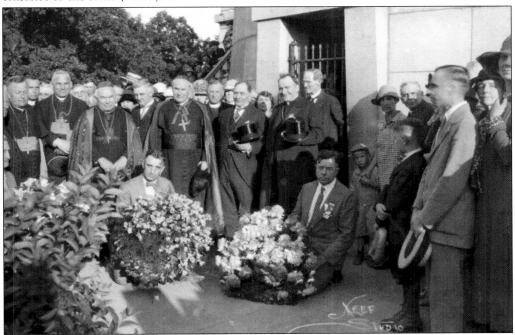

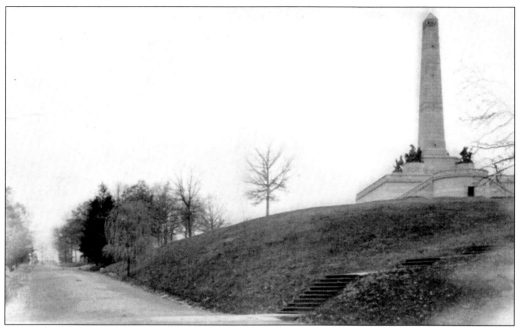

After its 1899–1901 reconstruction, the Lincoln Monument appeared able to withstand any weathering through the ages. These two views, taken in 1902 (above) and in about 1922 (below), show how little the tomb and its surroundings had changed in a generation. Major alterations were new concrete steps and a slight maturing of plantings as seen in comparing the two photographs. Despite continued interments and lot sales, the Oak Ridge board resisted all attempts to influence the State of Illinois to allow burials near the tomb. To maintain the peace and dignity of the cemetery, rules strictly prohibited children, "unless attended by some person who will be responsible for their conduct." Unfastened horses, smoking, and refreshments were also forbidden.

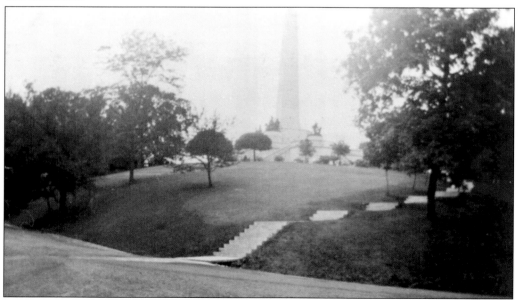

By the mid-1920s, the Lincoln Monument had again fallen into disrepair. The collection of Abraham Lincoln "relics" in the tomb's memorial hall were called "distasteful" by the *Chicago Post*, which claimed that "the spirit of sanctity is utterly lacking" and the "tomb has become a tourist-bait." The *Chicago Tribune* concurred, saying the collection gave the tomb "the appearance of an Old Curiosity shop." But, of greater concern, was the monument's physical condition. A leaking skylight made the interior musty and moldy, and state engineers worried about water leaking behind its granite veneer. An ambitious plan (below) by the GAR organization proposed a grand rebuilding scheme, including an open auditorium for patriotic activities and memorial hall for the GAR.

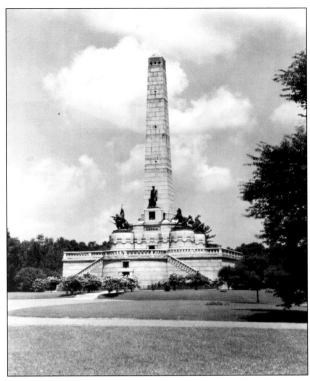

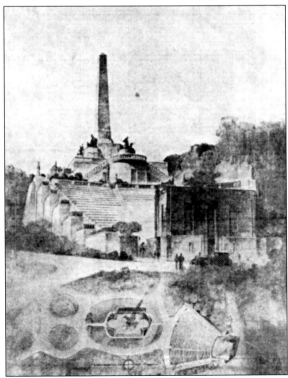

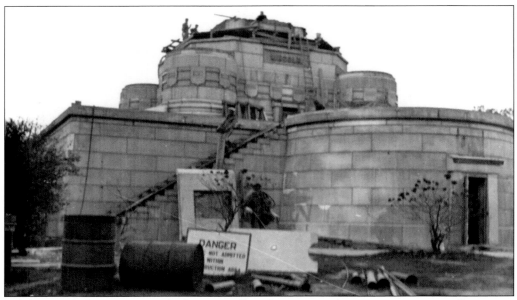

While it took 50 years to reach the one-millionth visitor to the monument, one million more people visited in the next 12 years. All this traffic, combined with a leaking building, made it imperative to develop a reconstruction plan sooner than later. In 1928, Illinois governor Louis Lincoln Emmerson made reconstruction of the deteriorating Lincoln Tomb a priority of his administration. New state architect C. Herrick Hammond supervised a complete rebuilding, including everything except the base. The statuary was again removed and stored as in 1900 and all granite facing removed, labeled, and stored. Concrete slabs replaced the terrace floor, and the leaking skylights were removed. The stone balustrade was repaired and replaced as needed. The first phases of reconstruction are shown in these two photographs.

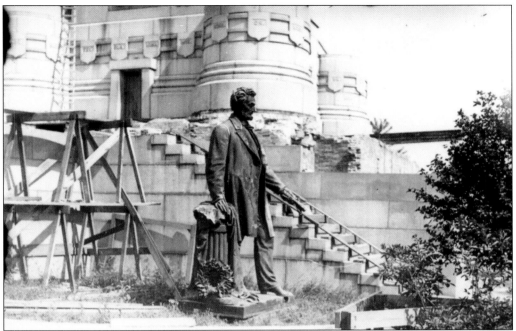

During the reconstruction the bodies of the Lincoln family were buried separately. Abraham Lincoln's body, of course, remained below the 10 feet of Portland cement enclosure. The bodies of Mary Lincoln and other family members were taken by "a distinguished party of officials" to the Oak Ridge Mausoleum and secretly marked so that no one except they knew the locations. The statue of Abraham Lincoln received a more public removal (above). The scaffolding (below) held the obelisk's stone cap during the renovations. During a windstorm the scaffolding was damaged and the cap, weighing over three tons, fell forward, crashing into the ground, just missing the terrace below.

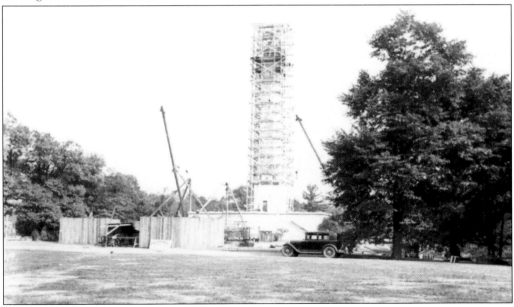

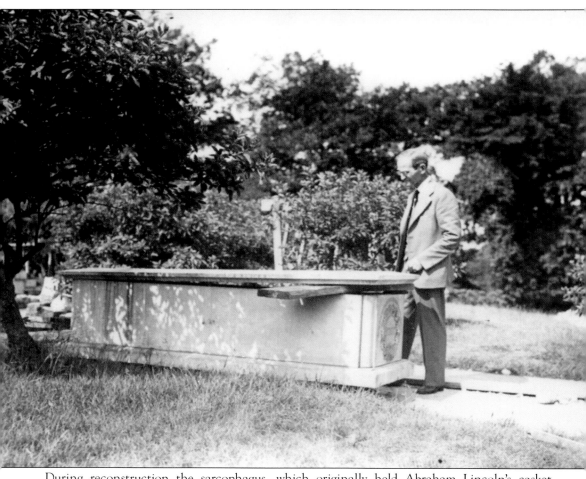

During reconstruction the sarcophagus, which originally held Abraham Lincoln's casket, became the center of a controversy. The marble sarcophagus was damaged by grave robbers, attempting to steal Lincoln's body in 1876. It had been stored in the tomb since then, including the years after Lincoln's body was buried below the floor. On July 6, 1930, Springfield's *Illinois State Journal* reported that "it was removed from the interior by workmen last week, and probably will not be replaced in the remodeled monument." Custodian Herbert Wells Fay poses here with the recently removed sarcophagus. Director of public works Harry Cleveland and architect C. Herrick Hammond had ordered it preserved. But the *Journal* reported in September that it had been found broken apart with pieces missing. Richard English, owner of English Brothers Contracting of Champaign, questioned his workers, who refused to lay blame or even discuss the incident at first. Custodian Fay believed the workers demolished it and souvenir hunters made off with missing sections.

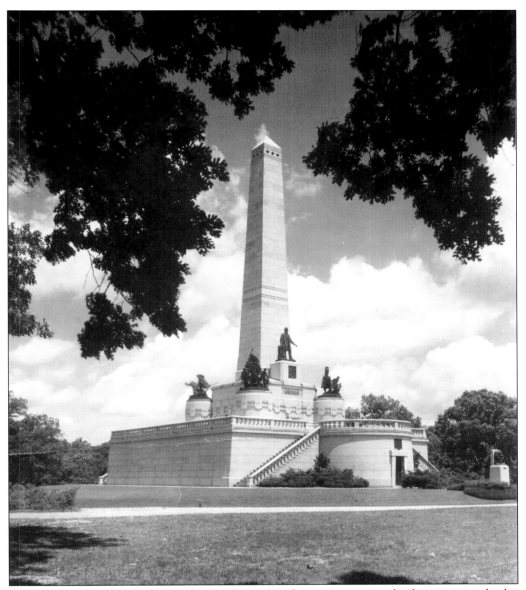

Despite the mysteriously damaged sarcophagus, crashing capstone, and other minor setbacks, worked progressed steadily and the rebuilt Lincoln Monument work was complete in 1931. By spring of that year, city officials were planning a major rededication ceremony. Custodian Fay had continually suggested that Lincoln's body be removed from its cement tomb, dusted up and displayed in a glass case for the public to see. Despite indications that this would not be done "in the present decade" Fay remained optimistic. "I believe that the time will come when public sentiment will demand that the body of Mr. Lincoln be placed in a sarcophagus for public view," Fay told the press. Although Fay's hopes were dashed, the public was delighted with the renovated tomb. The Illinois General Assembly passed a $180,000 appropriation request for the work, and the completed tomb is seen here in 1931 ready for public ceremonies.

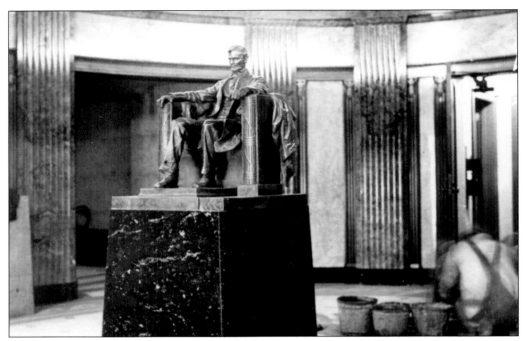

While the exterior of the rebuilt Lincoln Tomb appeared much the same, the interior was opulently transformed. It was rendered in a veritable quarry load of marble, accented with bronze grilles and gold leaf ceiling. A corn motif in the grilles replaced the more typical acanthus leaves of classical architecture. A new corridor led to the burial chamber, protecting visitors from inclement weather while they viewed Abraham Lincoln's burial place. This "splendid transformation," said former custodian Carol Andrews, was meant to create "an atmosphere of solemn and impressive dignity." It was to be "inviting, yet stately and reverent" and accommodate an increasing number of visitors. Visitors were greeted by the seated Lincoln (above) and walked past a reproduction of Daniel Chester French's Lincoln Park statue in Chicago (below).

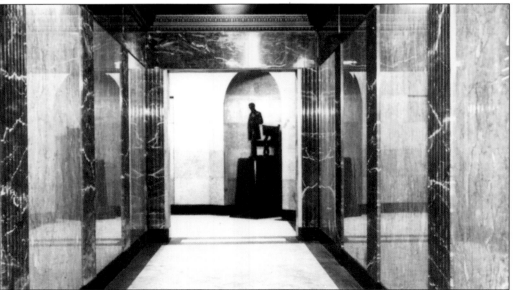

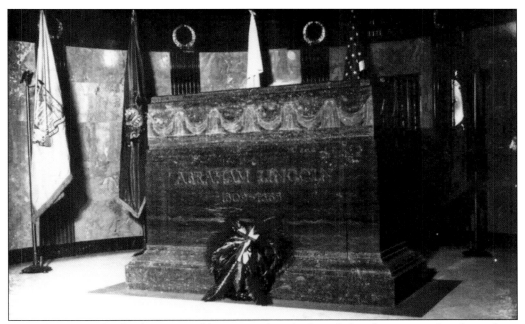

A simple cenotaph of Arkansas marble, centered in the burial chamber, covers the place where Lincoln's body is interred belowground. C. Herrick Hammond's assistant J. F. Booton designed "artistic combinations of marble making it the last word in architectural beauty." Custodian Herbert Wells Fay claimed that "world travelers place it next to Taj Mahal in India that cost 10 million dollars." While not the Taj Mahal, the tomb interior was impressive in its own right. The floor was "mainly Roman travertine, of whitest yellow shade." Italian marble panels along the passageway catch "the eyes of the guest and cause bursts of admiration." A circuit-riding Abraham Lincoln, seen in the statue below, seems almost lost amid this new grandeur.

Springfield was alive with excitement at the announcement that Pres. Herbert Hoover would rededicate the Lincoln Tomb. Preparations began weeks ahead. Gov. Louis Lincoln Emmerson and his wife planned a lunch at the executive mansion where cook Esther Gustafson labored long to prepare a dinner "fit for a king." Despite a great show of political unity between Democrats and Republicans, partisanship reared its head during the politically embattled president's visit. The Republican *Illinois State Journal* bravely claimed it was "a forgone conclusion" that "Illinois will be for Hoover." But that speculation was overwhelmed by continuing bad economic news. Next to one story on the festivities was a report of hunger marchers arriving south of Springfield. While a few lucky city residents received the invitation shown here, the rest were asked to wait to see the new tomb until all visitors had left town.

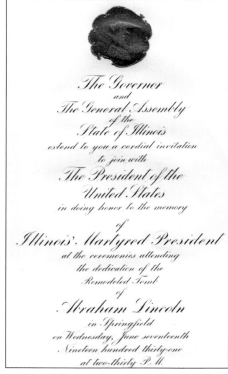

The Governor
and
The General Assembly
of the
State of Illinois
extend to you a cordial invitation
to join with
The President of the
United States
in doing honor to the memory
of
Illinois' Martyred President
at the ceremonies attending
the dedication of the
Remodeled Tomb
of
Abraham Lincoln
in Springfield
on Wednesday, June seventeenth
Nineteen hundred thirty-one
at two-thirty P. M.

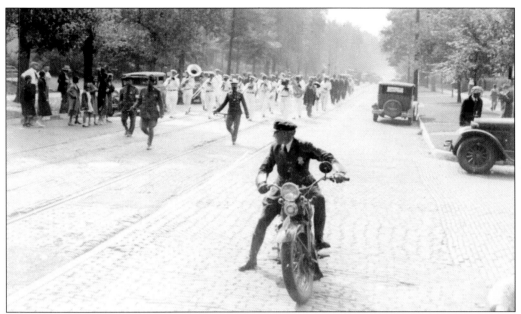

City and state police were nearly overwhelmed by traffic and crowd control details during President Hoover's visit. "A squad of eight state highway police on motorcycles scouted the streets" (above), and officials even called in nearly 700 Boy Scouts to help with traffic and visitors. Streetcars were blocked for two hours with passengers expected to walk. Several downtown streets were closed, and information booths for visitors were set up. Hoover, who arrived by "the same route" Abraham Lincoln had taken to Washington, spoke to the Illinois General Assembly, which convened at the old arsenal at Second and Monroe Streets. To reduce confusion, reserved first-floor seat holders were asked to approach the arsenal from the east, and those in the balcony were to approach from the west. In the meantime, preparations were getting underway at the tomb (below).

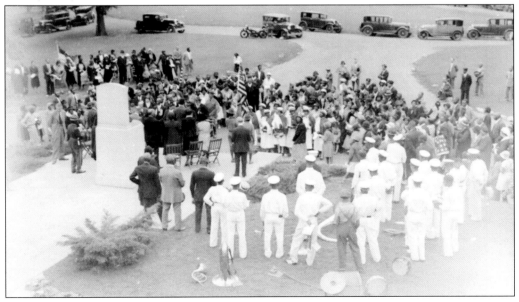

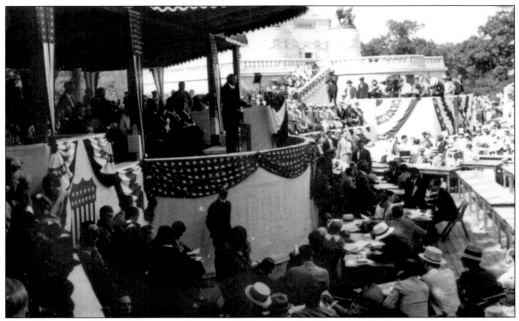

Traveling to Oak Ridge, the presidential motorcade passed thousands of spectators with Illinois National Guardsmen posted for security. An estimated 65,000 people gathered at the cemetery, and automobile parking was restricted to adjacent Lincoln Park. Pres. Herbert Hoover and his wife Lou Henry Hoover's arrival was greeted with "Hail to the Chief," courtesy of the University of Illinois band. On the speakers' platform (above) Gov. Louis Lincoln Emmerson introduced President Hoover as "a man who, like Lincoln, was called from the ranks of the common people to lead the country in an hour of adversity." A public-address system and "the invisible wings" of NBC and CBS radio broadcast the president live. "The eternal principles of truth, justice, and right, never more clearly stated than by Lincoln, remain the solvent for the perplexities and problems of every day and age," intoned Hoover to a Depression-scarred country.

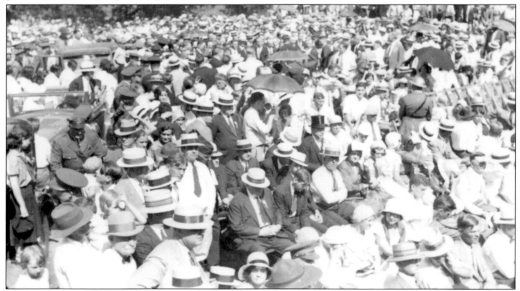

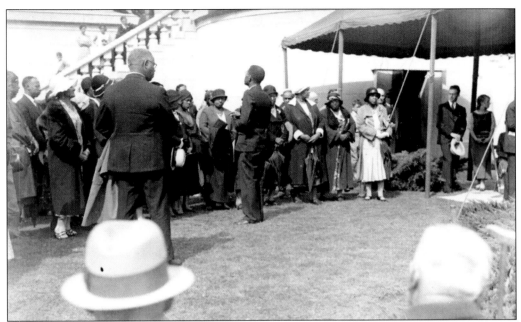

Music played a large part in the ceremony, from the "Star Spangled Banner" to works by Joseph Haydn. "Negro spirituals" were also prominently featured. Local musician William Dodd Chenery effused over James Mundy and his African American Lincoln Liberty Chorus (above). "Words cannot convey the fullness of his ability to gain the maximum of effect from the splendid company of singers of his race who reveled in pouring out their very soul in thankfulness at the tomb of their emancipator." Also prominent that day were members of the GAR organization. An old soldier (below) gazes reverently on a photograph of Abraham Lincoln. GAR members paraded proudly down Springfield streets, many remembering, through a nostalgic haze, the glory days of the Civil War.

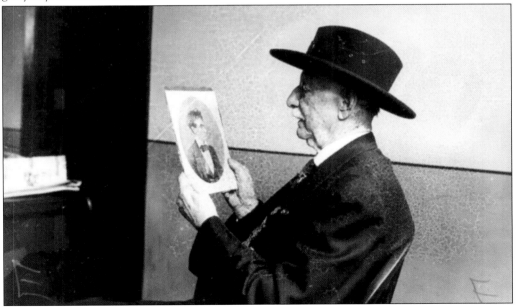

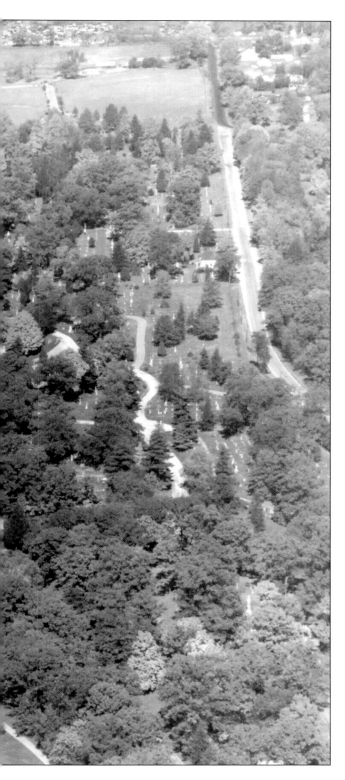

All the drama of reconstruction and rededication of the tomb seemed forgotten in a short time. An *Illinois State Register* article, only a few months after the ceremony, extolled the beauty of the ground but dismissed the tomb reconstruction as mere "remodeling." The "extensive" rededication ceremonies were noted, but the tomb "in essential appearance it remains the same. The interior has been changed, and a few feet added to the height of the shaft, but that is all." The rebuilt tomb nestled quietly in Oak Ridge's sylvan landscape that was now nearly 75 years old. Many visitors still preferred its tree-covered grounds to Springfield's numerous city parks. This aerial view, from the early 1930s, shows the tomb at left and marks the new age of air travel.

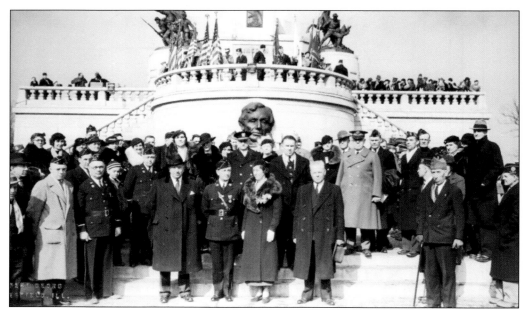

In the early 1930s, the newly reconstructed Lincoln Monument attracted nationwide attention and visitors. Tourism had become a major Springfield industry, and the Lincoln Tomb was an important part of that. As automobile ownership increased and new "hard roads" crisscrossed the country, groups and individuals made the pilgrimage to Abraham Lincoln's Springfield. Whether from across town or across the country, people came to pay homage to the slain president. Dozens of wreaths were laid at the tomb each year, and newspapers routinely ran photographs of groups from garden clubs to Kiwanians posing in front of the monument. Above, Springfield mayor John "Buddy" Kapp (center, right, hat in hand) escorts a group of American Legionnaires in the early 1930s. Tourists often purchased a postcard collection featuring the tomb on the packet cover (below).

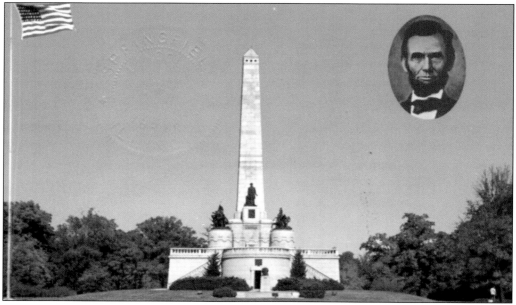

Three

THE CEMETERY BEAUTIFUL

Few people realize that it has taken 150 years of careful planning and maintenance to achieve Oak Ridge's present "natural" landscape. Designer William Saunders gave little supervision in carrying out his plan. And, as Oak Ridge grew from few acres in 1860 to 365 today, added sections were developed in a spirit sympathetic to Saunders's original scheme. This care has been the job of a succession of managers, groundskeepers, and board members.

One of the most dedicated of these was Dr. Henry Wohlgemuth, board member and president of the Oak Ridge board almost continuously from 1864 until his death in 1905. Wohlgemuth, a German immigrant and prominent Springfield physician, served variously as city physician, alderman, and member of the board of education and Sangamon County Board of Supervisors. He is also credited as the father of Springfield's waterworks. But Oak Ridge's care and beautification were clearly Wohlgemuth's greatest love. His great personal interest in Oak Ridge's landscape is documented in its annual reports—often written by him—containing much about landscape changes: plantings, grading, pond construction, and other items. He also visited several well-known rural cemeteries including Spring Grove in Cincinnati. After his daughter, Mariette's, death in the 1870s, he erected in her memory a large obelisk, topped with a statue of a young woman.

Wohlgemuth shaped Oak Ridge's rules and regulations and clearly modeled them on Spring Grove's. Trees could not be cut without permission, the board could remove any visually offending monument or structure, and no enclosures except stone curbing (no higher than three inches) were permitted on plots. Under Wohlgemuth's direction the cemetery grew into a beautiful, mature, and parklike landscape. One biography claimed that his "persevering and intelligent labors" changed Oak Ridge "from a rough and forbidding harbor for wild animals to one of the most beautiful cities of the dead in all our country." In addition to landscape improvements, Wohlgemuth and his board completed a new main entrance, replaced all original buildings, and added several new ones.

The rural cemetery movement inspired development of many city park systems in the United States. Oak Ridge may have influenced the location of an adjacent commercial park to the east. Oak Ridge Park (later renamed Lincoln Park) offered picnic sites and a quiet respite from city noise, odors, and crowds. Visitors came on foot, by horse, and, increasingly, on the city streetcar. Oak Ridge's main entrance was then on North Third Street, across from the park. The Catholic Calvary Cemetery opened on several acres adjoining Oak Ridge on the north. Altogether the two cemeteries and park gave the neighborhood a rural feeling close to the growing city. Oak Ridge Park (above), shown in the early 1900s, and Oak Ridge Cemetery (below), seen at about the same time, look much alike except for the gravestones.

Trees, plants, and a creek, as well as man-made monuments and grave markers characterize Oak Ridge's landscape. Early landscape designers and others complained about stone markers competing with nature's beauty. The ruggedly natural look of rural cemeteries began to change by 1870. A proliferation of monuments demanded a more manicured appearance, and cemeteries like Oak Ridge responded with large, open lawn areas. This became much easier after the invention of the lawn mower. These views from the 1880s show how the cemetery had filled with gravestones in its first generation. One history of American cemeteries noted that "even as critics complained about the loss of naturalism, the growing ostentation of the monuments, and the crowding of sections, Americans, proud of their success, continued to erect monuments to their past."

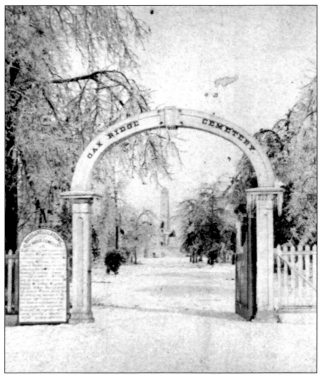

Oak Ridge Cemetery experienced a major change in orientation in the 1890s when the main entrance was moved from unpaved Third Street to paved Monument Avenue. This change gave a more formal entrance to the cemetery and was on a more direct route from downtown. The original Third Street gate (left), with its wooden arch, had become slightly deteriorated and old fashioned as the 20th century neared. America's rural cemeteries often designated an official "tour," a route that, when followed, showed the landscape to its greatest advantage. Oak Ridge's version is outlined on an 1872 map and began at the old gate. A grander stone and iron entrance gate, fence, and office were built facing Monument Avenue in 1900. The Third Street entrance was rebuilt for pedestrians.

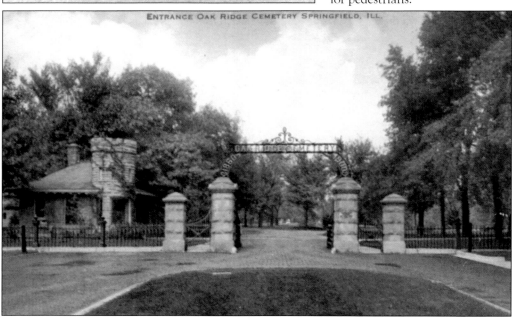

The simple board fencing that once surrounded Oak Ridge was gradually removed and, eventually, replaced with the woven wire fence of today. For a time a typical 19th-century iron fence partially enclosed the cemetery. The former main entrance on Third Street became a pedestrian gate about 1900. Decorative iron fencing that once surrounded the palatial home of former governor Joel Matteson was installed, along with stone curbing, on Oak Ridge's Third Street property line. Matteson's grand house, across from the Illinois executive mansion, burned in the 1870s. The fencing was "so wrecked by heavy rains in 1918 that it was taken down and a heavy concrete wall erected in its place" (below).

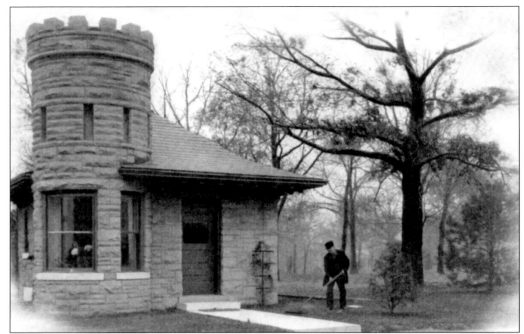

In the late 1890s, the Oak Ridge Cemetery Board of Directors embarked on a massive rebuilding program. In addition to the new main entrance structure, they contracted for a new office, chapel, and bell tower, as well as homes for the cemetery and tomb custodians. The rustic stone gatekeeper's office (above) was the work of locally renowned builder James Culver. In the late 1940s, it was doubled in size using stone taken from the chapel and remodeled into a large office. A Colonial Revival cupola was added to the roof and the interior completely updated. Mayor Harry Eielson and Oak Ridge officials stand outside the completed office in the 1949 photograph below.

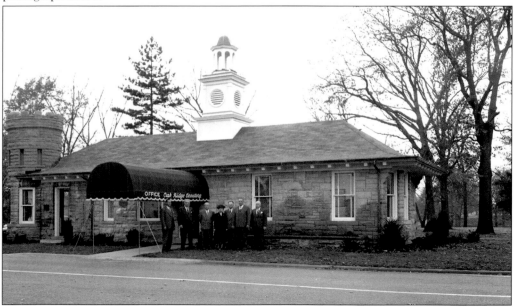

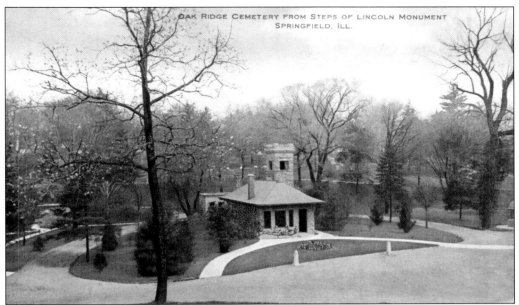

The chapel/office was completed as part of Oak Ridge's 1890s building program. With its tall, ivy-covered tower and overhanging, bell-shaped hip roof, the building was a charming addition to the Oak Ridge landscape. Beneath its quaint, cottagelike appeal the "massive stone structure" contained a modern records office and "fire and burglar proof vault, intended for the safe keeping of cemetery records, maps, papers, etc." Further, "the said building can also be used for a Chapel on funeral occasions." In addition to new buildings, a general improvement in cemetery infrastructure was undertaken. The receiving tomb was remodeled, and cement walks appeared, along with two ornamental stone drinking fountains. This building was dismantled in the 1940s, leaving only the bell tower standing and the materials reused for an addition to the entrance gatehouse, which became the cemetery office.

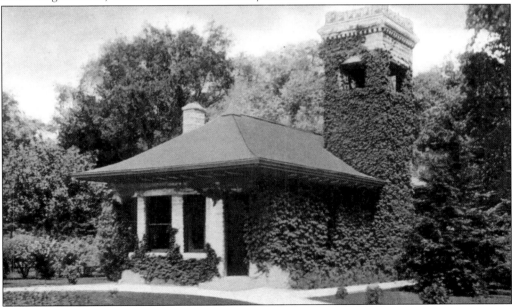

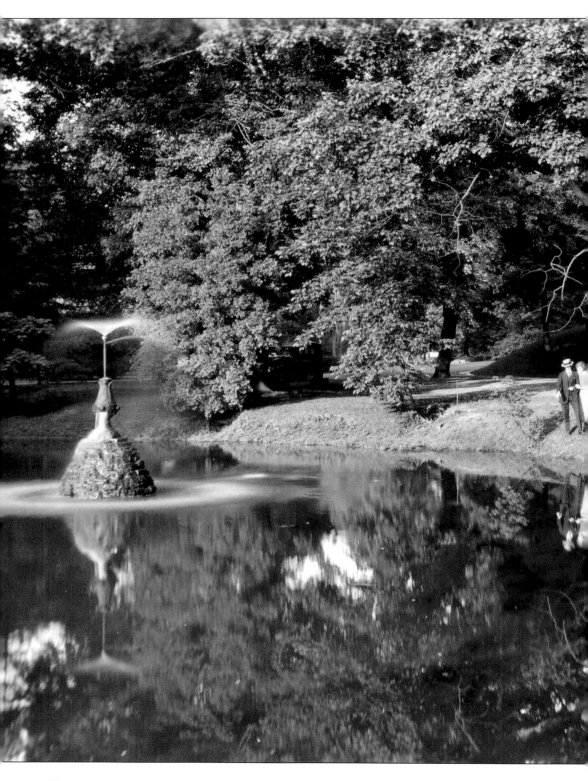

Oak Ridge Cemetery was a popular destination for amateur and professional photographers. Springfield photographer Edgar Kluckman composed this romantic view of a young couple viewing their reflection in the cemetery's pond. Constructed in the 1870s, the double ponds may have been part of William Saunders's original design. They functioned for storm water drainage and were fed from a Spring Creek tributary running through the cemetery. The decorative fountain at left also served to aerate the water and prevent stagnation. The ponds were located across the road from the receiving vault and were filled in sometime in the 1940s. Today a line of magnolia trees mark the pond's former location and provide a memorable springtime flowering.

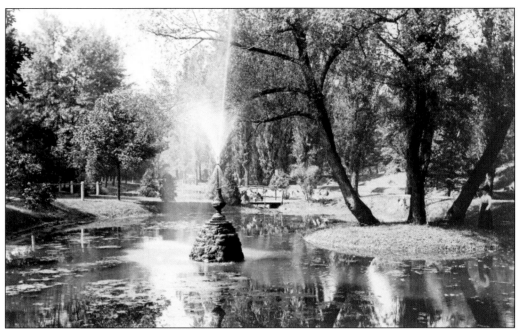

The ponds at Oak Ridge were a popular feature for many years, particularly before city parks with their own ponds existed and long before Lake Springfield was constructed. In the late 19th and early 20th centuries, visitors enjoyed Oak Ridge much as they would a public park. The lush landscaping let people be in nature and yet close to the city. Many people continued to enjoy Oak Ridge's landscape even with the opening of new city parks after the founding of the Springfield Park District in 1900. The photograph above shows the original, wooden, rustic bridge that was replaced about 1900 with the more permanent stone structure seen below.

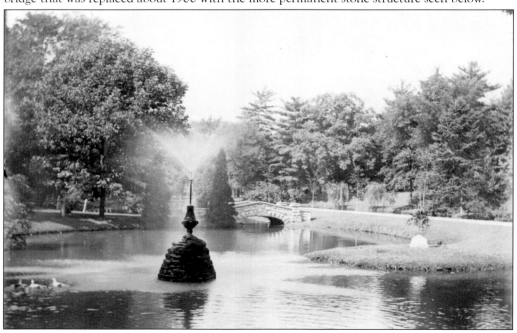

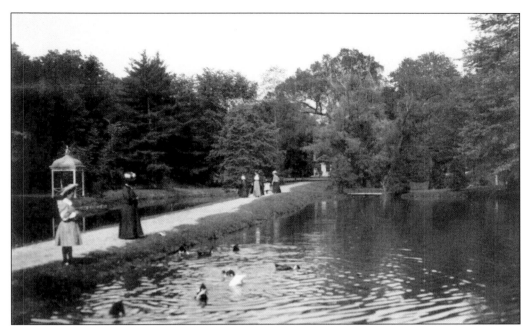

Duck feeding was a popular pastime on Sunday afternoons at Oak Ridge. This 1908 photograph captures the atmosphere of peace and quiet, which drew visitors in large numbers. Some Sundays, however, became so crowded that it was difficult to find a secluded area. Shown here is the earthen barrier dividing the pond and providing a natural walkway.

The entire cemetery, not just the areas near the ponds, had handsome, mature landscaping by the early 20th century. In addition to the oak trees that gave the cemetery its name, exotic species like the weeping willow at far right were planted for a romantic effect. The heavily tree-planted edges of the cemetery screened out views of the surrounding neighborhoods, giving a feeling of escape from the everyday world.

Oak Ridge quickly became known as one of Springfield's most beautiful spots. "From an inauspicious beginning of 15 acres of sprawling, densely wooded acres," said one writer, Oak Ridge Cemetery "has become famous for its scenic beauty, and has gained world renown as the setting for the tomb of Abraham Lincoln." Several miles of roads "winding in picturesque fashion through the hilly terrain" added to its appeal. Photographers never tire of recording Oak Ridge in every season. Above, the stark contrast of a winter snowfall outlines the landscape about 1920. In the 1910 scene below, the green of summer is further embellished with a lushly planted urn near the main entrance.

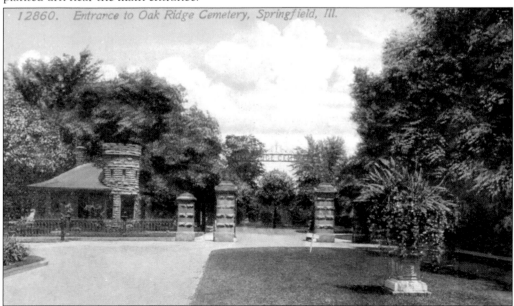

12860. Entrance to Oak Ridge Cemetery, Springfield, Ill.

By 1940, the permanent cemetery population had grown to over 33,000 and its board purchased additional land to the west. This new section was laid out in similar design but with wider, less sharply curved roads to accommodate the wider radius needed for automobiles. Monument regulations, reflecting changing fashion, now limited the size of grave markers in this section. By the mid-20th century, Oak Ridge administrators believed that the automobile would dominate the cemetery and require its own entrance. Consequently, in 1941, the Springfield City Council designated a new, "picturesque" widening and landscaping of Walnut Street from North Grand Avenue, north to the new western entrance. The original, utilitarian woven wire gates at the Walnut Street entrance (above) were replaced with more monumental limestone gates and piers about 1960 (below). Also gone was the sternly worded warning sign.

Not surprisingly Oak Ridge Cemetery's "neighborhoods" reflect those in Springfield. The highest elevations are occupied by the graves of some of the city's wealthiest families, mirroring Springfield's old Aristocracy Hill neighborhood. Other areas are heavily Irish or German or Eastern European. A 1931 news story reflected segregation then experienced by Jewish residents, mentioning Oak Ridge's "special section of about one and one-half acres which is used exclusively by the Jews of the city." The most controversial, particularly in recent years, was the Spring Hill section, shown above, where, for generations, black families were buried. Located in a low-lying area near a refuse pile, it came to general attention in news stories in the 1980s. The potter's field (below) is almost totally without grave markers.

The living have long resided at Oak Ridge Cemetery along with the dead. One of the first was sexton George Willis, who was employed as early as 1858. In those days it was common for people to live close to work, even above the store, and a cemetery was no exception. The Willis family occupied the wooden cottage (right) seen in this 1860s photograph. Its rough, wooden tower held the bell tolled at funerals. The bell was moved to the new tower in the 1890s, but changing customs led to its discontinued use by 1940. Cemetery superintendents and their families occupied the little house overlooking Third Street until the 1890s. The Lincoln Monument custodian and family lived in the miniature castlelike house below, built in 1896. The section to the left of the turret was added after 1900.

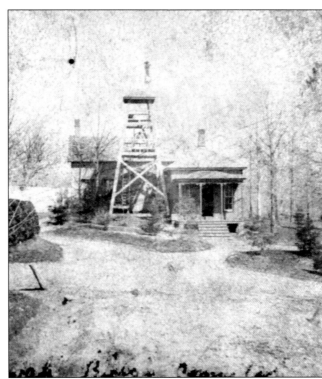

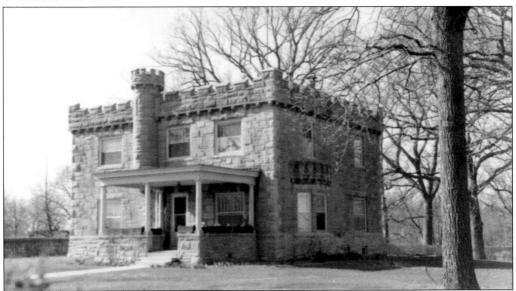

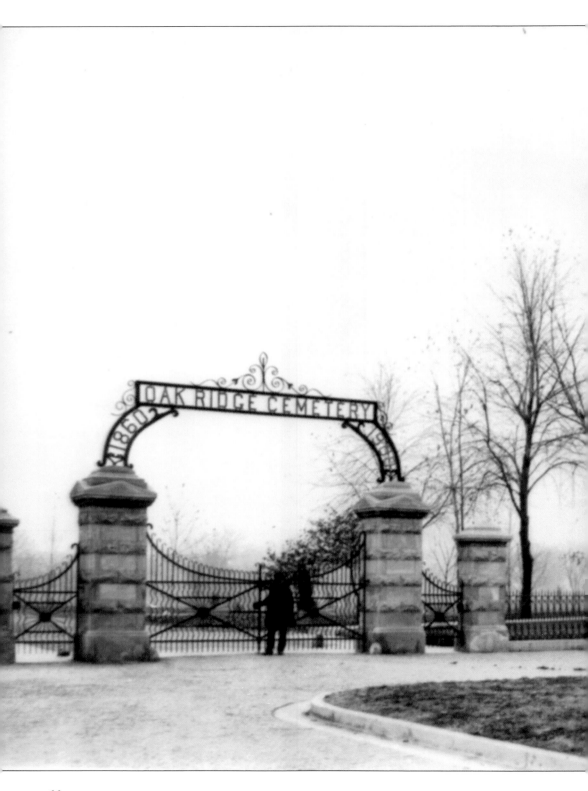

In 1899, while the Lincoln Tomb was undergoing reconstruction, the Oak Ridge Board voted to move the main entrance to newly paved Monument Avenue and erect a handsome stone and iron gateway. At the same time they authorized purchase of a lot to the east for a new superintendent's residence, seen here at right. The old cottage, which also served as an office, was "not only in a bad condition, but not safe for the proper keeping of records, charts, maps, and papers." John Gaupp and family were the first to occupy the new house, but when their daughter, Edith, died in 1904, the Gaupps wanted to leave the cemetery. They built a copy of this house on the southwest corner of First and Elliot Streets, which is still standing today.

The Museum of Funeral Customs was opened on the site of the superintendent's house in July 2000. Despite an outcry by preservationists, the century-old house was demolished and a new building for the museum constructed. Living at the cemetery was a very unpleasant experience for inmates of the isolation hospital (below), commonly known as the pesthouse. From about 1870 to the early 1920s, patients with contagious diseases were housed here with only a married couple as caretakers. Physicians made visits, but, said one newspaper, other "visitors were conspicuous by their absence. One young inmate reportedly told a friend 'They've got me out here at the Pest House . . . Pray for me! They ought to have a sign over the door: 'Abandon hope, all ye that enter here!'" It was rebuilt in 1902 and demolished in the 1920s or 1930s.

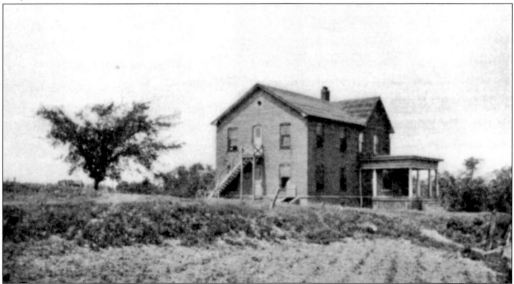

Four

MEMORIAL ARTISTRY

While people have always marked graves in some way, the art reached new heights in late-19th-century America. Victorian art and social ritual grew progressively more elaborate, and gravestones mirrored that trend. This was true especially in America where, according to historian Walter Creese, "there seemed to be an irresistible urge to reassert individuality and family memory at a grand scale." Creese cites American individualism as primarily responsible for these imposing grave markers. And new mechanized stonecutting equipment made highly ornamented markers easier and cheaper to produce. Plain and simple marble and limestone markers of the early 1800s gradually gave way to expensive decorated stones.

An entire language of symbolism also evolved. Beyond traditional crosses and urns, the Victorians developed a rich iconography of other symbols. A sheaf of wheat could represent a long and fruitful life. Keys, ivy, draped urns, doves, broken tree trunks—all appeared in stone, rich with meaning to mourning family and friends. Springfield residents knew this language well. At the 1860 dedicatory address James Conkling spoke movingly of "the broken column" with its "emphatic tones of shattered hopes and blasted expectations. The funeral urn reminds us of the dust and ashes to which we shall finally be reduced." Further, the rose bud signaled a child's death, and the "smiling cherub" brought ideas of heaven, while "the cross, the grand center of attraction, proclaims that the affections are crucified." Conkling's audience doubtless agreed with his passionate declaration: "Oh! What lessons of wisdom may here be learned! What gems and pearls of inestimable value may here be gathered upon the shores of eternity!"

Art and social life eventually simplified, so too did gravestones. A gradual informality coming into everyday life is reflected in the far simpler monuments and markers of the 20th century. Eventually simple blocks of granite, set flush with the ground, came to be a kind of standard-issue marker common in American cemeteries. Oak Ridge's monuments and markers reflect 150 years of America's changing fashion in art and architecture.

By the late 20th century, the original sections of Oak Ridge had filled with monuments and markers of every type and style. The Lincoln Monument (left), with its rising obelisk, towers over all others. Below, in the words of one 19th-century speaker, "the lofty column elevates the affections above the world and directs them upward to the skies." Columns had been an integral part of classical-styled architecture for centuries, but they were given a large boost in popularity after the Chicago world's fair of 1893. The exposition was clothed in classical revival temples with friezes, porticos, balustrades, and, of course, classical columns. Business partners, newspaper owners, civic leaders, and intimate friends, Thomas Rees and Henry Clendenin commemorated their friendship in a joint family monument. The new monument (below) is seen in 1925.

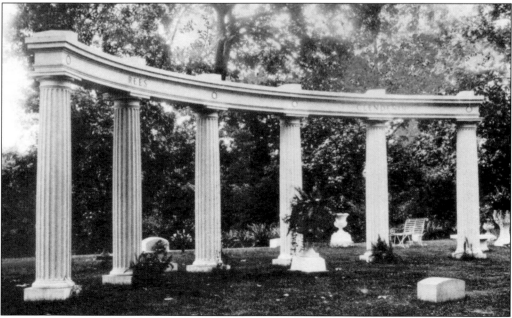

These small stones, although overly sentimental by today's standards, are nonetheless still touching. The infant Rosette children, watched over by their loving dog, were skillfully carved in the 1860s for their grieving parents, who must have visited the grave countless times. John Rosette was Springfield's "best criminal lawyer," who lived in a modest north side neighborhood of Portuguese and Italian families but kept a fashionable carriage at a time when comparatively few families could afford one. Erastus Wright, one of Sangamon County's first teachers, is memorialized in this elaborate marker. These tree stones were part of the Victorian rusticity movement, related to iron lawn furniture that imitates wooden twig construction.

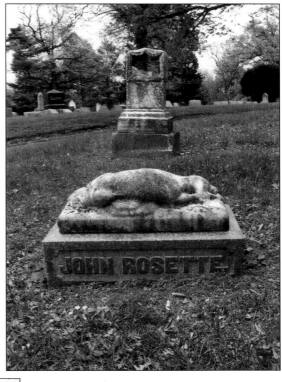

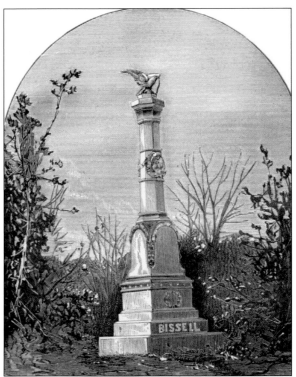

The obelisk and column have been associated with memorials since classical times. But they proved especially popular for American 19th-century grave markers. The two shown here are exceptional examples. The one at left was designed by famed architect Elijah E. Myers for Gov. William Bissell, Illinois' first Republican governor, as well as "patriot," "statesman," and "hero," according to his monument. When Oak Ridge board president Dr. Henry Wohlgemuth's daughter, Mariette, died, he poured out his grief by lovingly designing her monument (below). Wohlgemuth sent his column design, "with mounted scrolls on three sides for inscription," to G. Leslie Jameson, of the Crown Granite Works, Aberdeen, Scotland, to build. The figure of Hope at the top was designed and sculpted in Italy. The 22-foot-high monument was "considered the finest and best designed monument in the Cemetery" at the time.

The heroically scaled obelisk (right) memorializes the scandalous affair between defrocked Methodist minister William Rayburn and a parishioner named Mattie. The minister, recalled Springfield resident Isaac R. Diller, "was strikingly handsome" and "was charged to have advocated the doctrine of free love." After an 1891 tour of the Holy Land, an ailing Mattie died in New York, and the Reverend Rayburn raised funds to erect this monument. The 40-foot-high column, supporting a statue of Mattie, was seen as a monument to the couple's love and a reprimand to those who snubbed her in life. Below, the memorial to J. W. Northcott, erected in 1917, recalled him "friendly as a wayside well." Even in death Northcott's monument offers a seat to passersby.

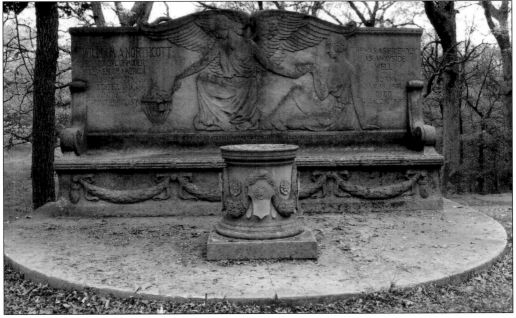

The architectural character of many Victorian monuments is apparent in these two examples. The marker at left resembles a miniature church or government building with its arched openings, classical columns, and domed roof. Monuments like this one were lower-cost answers to building family mausoleums. The houselike Vredenburgh gravestone (below) is particularly appropriate for the family that owned the city's leading lumberyard, whose products were used to construct thousands of Springfield houses in the 19th and 20th centuries. In addition, the Vredenburghs owned an entire town and large tracts of timberland in Alabama. Children of founder John Vredenburgh lived large with their immense wealth. One son remodeled a plain 1850s house into an ostentatious showplace with an extensive garden. He held legendary parties there in the 1920s and 1930s. Another son was killed in a racing accident in 1910.

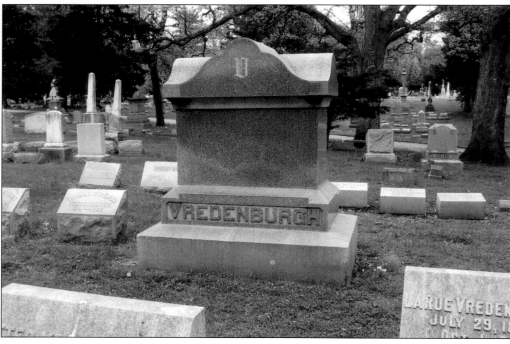

The unusual John Krous monument (right) displays his photograph and a casting of his beer garden, popular with Springfield's large German population from 1875 until his death in 1893. His widow sold the business and remarried within nine months. The garden fell into a "resort for low classes of both sexes, who turn night into a bacchanalian dissipation." More conventional is the red sandstone mausoleum (below) erected by Orson Stafford, a New York native who went to sea at 13. A shipwreck disabled him for life. Coming to Springfield in 1837, Stafford took up shoemaking and became a prominent merchant, house builder, newspaper editor, alderman, and corn planter manufacturer. Stafford owned extensive orchards near St. Augustine, Florida, where the couple wintered. He was buried in 1891 alongside his infant daughter and followed later by his widow, Eliza.

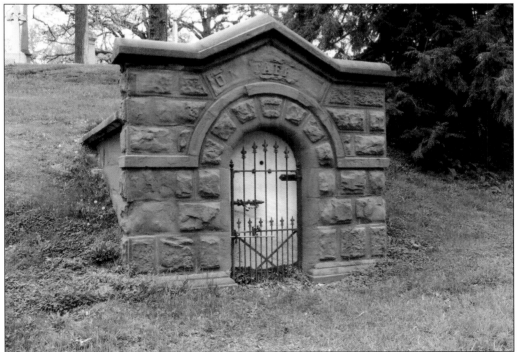

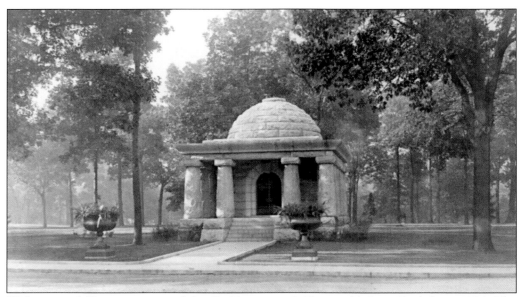

Widower and Illinois governor John R. Tanner wed 32-year-old Cora English in 1896. The couple had celebrated only a few years of marriage when Tanner died on May 23, 1901. The popular Republican governor's friends, including Illinois coal miners, raised funds to erect this handsome mausoleum for him. Only a short distance from the Lincoln Tomb, the massive, domed structure, constructed of rough-hewn granite, was dedicated in 1908. Grille-covered windows and doors open to an interior containing a bust of Tanner and a catafalque. At the dedication ceremony politicians, a judge, a newspaper publisher, and a labor leader heaped praise on Tanner. His two favorite songs, "Illinois" and "Nearer My God To Thee," were performed and "the interior was draped with American flags and banked with . . . large vases of magnificent American Beauty roses."

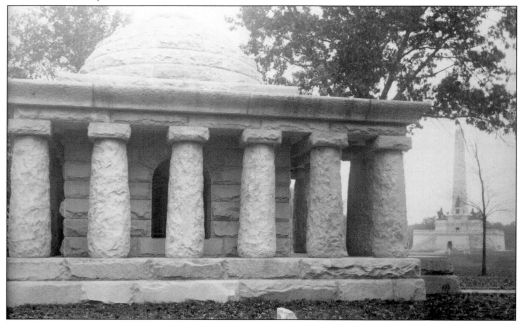

While much smaller than the Tanner Mausoleum, the Cowgill Mausoleum is a small gem, elegantly carried out in design. Constructed about 1927, the mausoleum is a simple, rusticated temple-form structure. Two steps on the south lead up to a base of rough-finished stone. The mausoleum's walls are built of massive blocks of rough-finished stone and a frieze is formed of large, rough-faced stone blocks. The roof is a two-part, pyramidal shape with pediments on the north and south. The only opening is through a pair of iron grilled doors (right) decorated with palms and simple geometric squares on top and bottom. This opening is framed with simple, unpolished trim, capped with a smooth section of frieze where the name Frank Sayer Cowgill is carved.

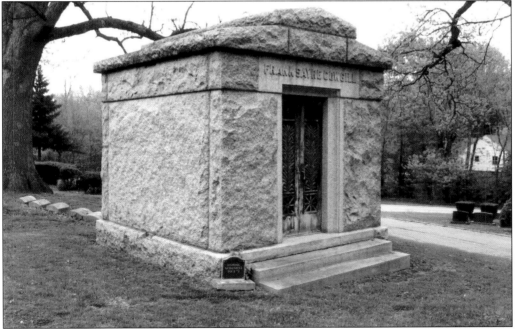

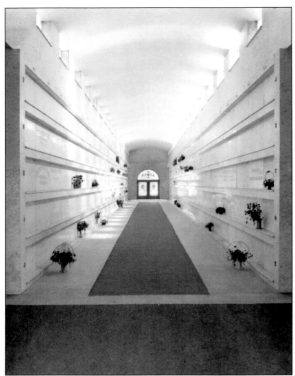

The largest building in the cemetery is Oak Ridge Abbey. This limestone-faced structure has a central, arched entranceway flanked by matching wings with modified mansard roofs. The private company that built and managed the mausoleum in 1911 referred to it without irony as "America's Westminster Abbey." It contained 1,051 burial spaces and measures 135 feet long and 83 feet wide. All construction materials were pronounced "indestructible" and consisted of reinforced concrete, Bedford stone, tile, copper, and marble. The abbey was forecast to last many centuries. Crypts were less expensive than regular burial lots and remained "always dry and sanitary." J. A. Morton, manager, was available at his office in the Ferguson Building downtown to discuss terms. The marble-lined interior (left) remains as visually antiseptic as in 1912. The newly completed building is shown below in a promotional brochure.

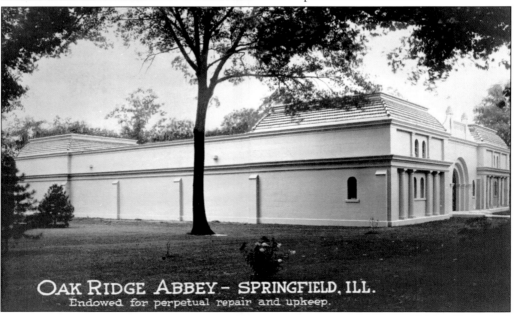

OAK RIDGE ABBEY – SPRINGFIELD, ILL.
Endowed for perpetual repair and upkeep.

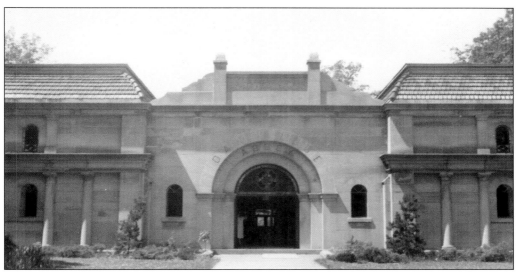

Despite assurances of an adequate management fund, the Ohio-based National Mausoleum Company was in receivership before the building was finished. Company owner William Hood made sworn statement that the company owed no debt and would continue in business. After several years of continued wrangling, the operations of the mausoleum were finally taken over by the Oak Ridge board of managers. The photograph above shows the building in the 1920s.

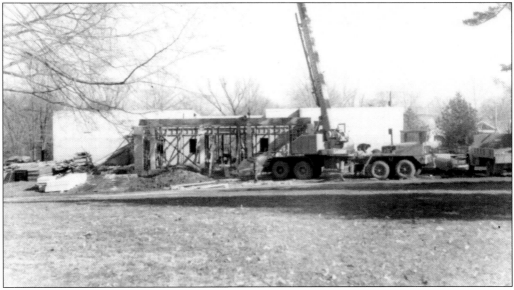

Even with all the management troubles with Oak Ridge Abbey, its aboveground burial form remained popular with some Springfield families. As it neared capacity, Oak Ridge board members proposed construction of a new mausoleum 60 years later. This project would be handled entirely by the City of Springfield and the cemetery. It was located across the road to the east of the abbey and is shown under construction in 1974.

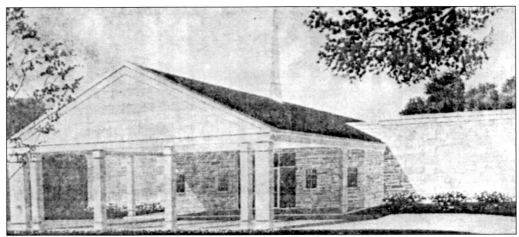

The new mausoleum was officially designated as the Oak Ridge Cemetery Memorial Chapel Mausoleum. The architect's rendering (above) shows a much less ambitious building than the original abbey. It contained only 500 crypts and has not been enlarged since opening. A modified Colonial design allows for a covered portico for guests arriving by automobile. The stone-faced building has windows only in the entry. Lighted, marble-lined corridors (below) are reminiscent of the original abbey. The major difference here is that all interiors are enclosed, heated, and cooled. No cost estimates were given, but it was prudently reported that it would be "funded by Oak ridge Cemetery Board, and no debt will be incurred."

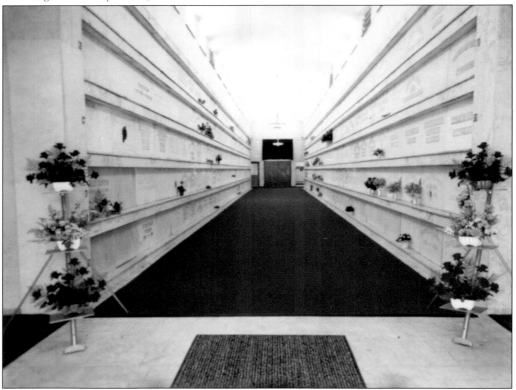

One of Oak Ridge's first reserved sections was set aside for children from Springfield's Home for the Friendless. The home was founded in 1863 to deal with widows and orphans homeless in Springfield, having fled from border states during the Civil War. Shortly after the war, funds were raised to build the grand structure seen at right. The home operated from here until the 1930s and is ancestor to today's Family Service Center. Over 600 children were buried in the Oak Ridge lot between 1863 and 1904. The Oak Ridge Board also set aside a burial mound for the GAR (below). It provided a burial place for Union army veterans. Historian Floyd Barringer notes that the first burial here was for Matthew Henry in 1891 and the last for Cinley Diehl in 1930.

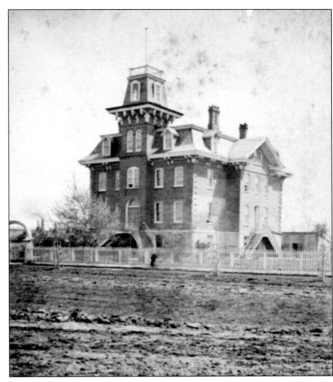

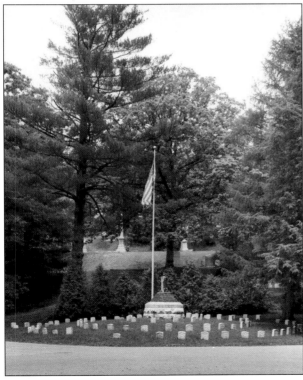

The large military monuments of the 20th century had their origins in the small-scale war memorials of the 19th century. Typical of these is Oak Ridge's soldier's monument to Civil War veterans. The Illinois State Sanitary Commission, which aided soldiers during the war, disbanded in 1872 and donated its funds to the National Lincoln Monument Association. The association erected this obelisk in 1874 (left), dedicated to Civil War soldiers buried in the cemetery. The World War II monument (below) is the newest, with planning started in 1999 after several veterans at an Illinois reunion asked to see their monument. After learning there was none, they began fund-raising, which produced this design of illuminated, white concrete globe and two black granite walls. The walls are inscribed with details of Pacific and European battles.

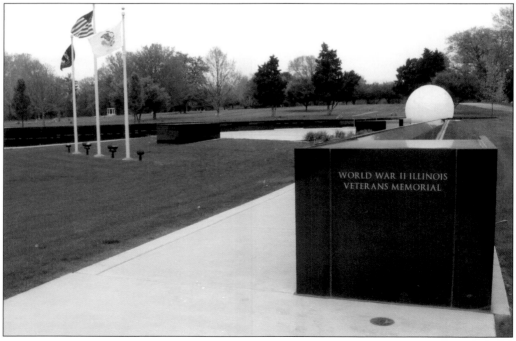

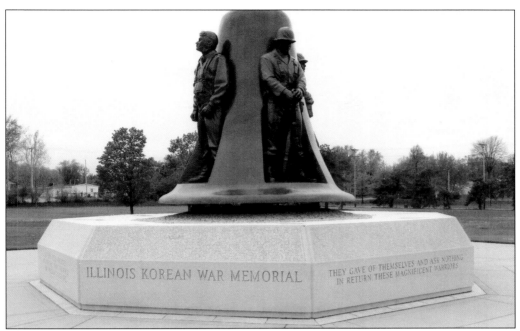

The bronze and granite Korean War memorial (above) was dedicated in June 1996. Names of 1,752 Illinois veterans killed in Korea, along with patriotic quotations, are inscribed on the octagonal granite wall at its base. The centerpiece is a 12-foot bronze bell and statues of four soldiers in guard stance. Vietnam War wounds began to heal with the 1982 dedication of the Washington Vietnam Veterans Memorial. Shortly after, plans began for the Illinois Vietnam Veterans Memorial (below) at Oak Ridge. The memorial fund association was headed by marine Pvt. Michael Ferguson, of Decatur, who lost his legs on a land mine in 1967. The 15-piece black and gray granite monument, dedicated in 1987, contains the names of the 2,948 Illinois veterans who did not return. Touching those names "just gives you goosebumps," said Ferguson at the time.

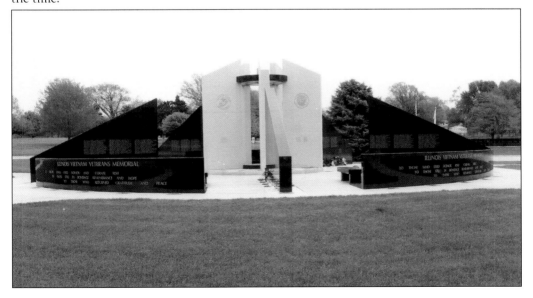

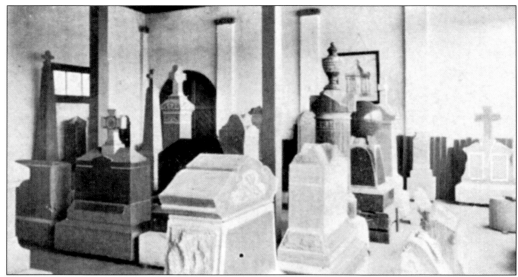

Nearly all of Oak Ridge's grave monuments were created locally. Many from the late 19th and early 20th centuries were purchased from the Baum Stone Works at Tenth and Jackson Streets. Founded in 1865 by Cologne, Germany, native, Joseph Baum, and eventually purchased by his son, Martin, it became the oldest and largest business of its kind in the city. Baum employed 15 to 25 workers using "the most powerful and modern machinery" requiring "two tons of coal a day" to operate. These included a six-ton rubbing bed, "Jenny Lind granite polishing machine . . . Reihl molding and counter-sinking machinery . . . [and] pneumatic tools used for cutting." The rough stone, which was transformed into artistic monuments, was delivered on the railroad tracks running alongside the firm's building. Every stone on the Baum lot at Oak Ridge came, naturally, from the family business.

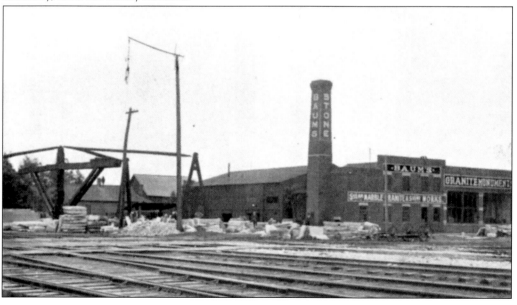

Springfield boasted several monument makers, including Col. James Culver (right) and J. L. Fortado (below). Culver sometimes provided stones as a very small part of his very large stone business. He built Springfield's old Lincoln Library, arsenal, and Oak Ridge buildings. He also rebuilt the Lincoln Monument in 1899. A flamboyant, outspoken, and charming man, his canny business sense and occasional bluster helped him rise from obscurity to influence. Local political and social leaders and more than one governor were numbered among his friends. He died in 1911 while supervising construction of the Leland Hotel. J. L. Fortado was a Portuguese stonemason who built a successful business in "granite, marble, stone, slate, and roofing tile" along with gravestones. He proudly displayed a photograph of himself along with examples of his work in this 1902 advertisement.

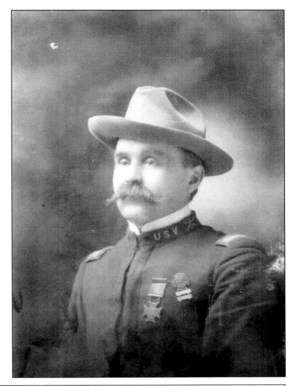

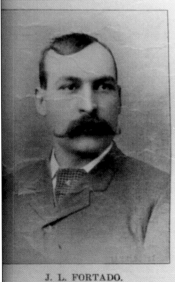

MARBLE PLAIN GLAZED ENAMELED EMBOSSED | WAINSCOATING AND WALL TILE | TILE FLOORS | MARBLE ENCAUSTIC VITEROUS MOSAIC

J. L. FORTADO

Contractor for and Dealer in

Granite, Marble, Stone, Slate

AND ROOFING TILE.

Monuments and Cemetery Work of Every Description

N. E. COR. TENTH AND MONROE.

Residence Tel. 2851.
Office Tel. 2031.

STONE WORK ARTISTIC
OR PLAIN.
For
BUILDING and ALL OTHER
PURPOSES

ALL KINDS OF
SLATE AND TILE ROOFING
AND REPAIRING.

J. L. FORTADO.

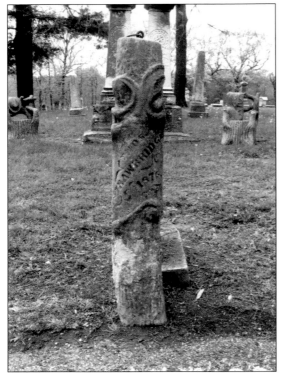

Highly carved Victorian grave markers are often rich in symbolism. While many exhibit one or two motifs, Thomas and Mary Strawbridge's monument overflows with language for the initiated. Thomas came from Ireland as a child and was Sangamon County's first saddle maker. He was also a prosperous farmer, never marrying but later sharing his home with his widowed sister Mary. At his death in 1880, he left money to the Home for the Friendless and for an annual Strawbridge sermon given in several churches yet today. The Strawbridge monument (below) is the work of artisan Edward Levanius. Its wheat marks a long, useful life, and wreathed urn, broken tree, and fallen roses signify death. Empty rustic chairs on either side contain Thomas's hat and Mary's cloak. Nearby is a reminder of Thomas's occupation—an ornate hitching post (left).

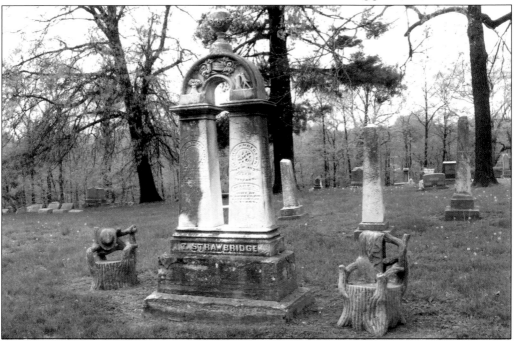

By the early 1900s, as Victorian fussiness became increasingly outdated, grave markers also became much simpler. A good example of this plainer style in middle-class grave markers is seen at the graves for John and Emma Samuelson (above), photographed at John's funeral in May 1915. John Samuelson emigrated from Sweden and eventually made his way to Springfield where he worked for a farm implement company. When he died of pneumonia, at age 70, he was survived by his widow, two married daughters, and a son still living at home. These plain, arch-topped stones have only the basic information about the descendants and forego the sentiments once so popular. Below, this modest infant's stone shows how simple markers were becoming after 1900.

The design of gravestones became simplified beginning in the early 1900s, reflecting modern artistic ideas. This was true of even the most monumental among them. The grand stone at left was designed and built by Springfield's Baum Stone Works for owner Martin Baum, who died in 1917. Had this been created a generation earlier, it doubtlessly would have had elaborate surface decorations and, perhaps, columns, arches, or rustic stonework. But, by 1917, this chaste monolith's surface was broken only by a floral cross and raised letters. The massive angularity of the Baum stone is reflected in a more modest version of about the same time (below). Francis and Sarah Thomas's monument, formed from a solid block of polished granite, makes a striking, geometric statement.

Springfield's Vachel Lindsay was a poet with an international reputation who was at the height of his popularity about 1920. He was lionized and feted across the United States and had the following accorded to some actors or rock stars today. Just a decade later he was nearly forgotten by the public and suffering deep despair. He took his own life in 1931, worn out with worry over finances and personal problems. Despite his once giant reputation, his Oak Ridge marker is modest, something that would no doubt have pleased the unconventional, self-proclaimed troubadour. The stone of Laomi Herndon Brown (below), niece of Lincoln's law partner William Herndon, is similarly clean-lined. It is conspicuous among the elaborate Victorian markers and highly polished stones of her relations buried nearby. These 1930s designs anticipated styles popular in the coming decades.

After many years out of fashion, grand monuments again appeared in Oak Ridge, recalling the individualism and scale of Victorian examples. Roy Bertelli, left, "lived for one thing, and one thing only—accordions." Two wives left him, but his accordions remained loyal all his long life. He conceived an idea to memorialize himself and his career by purchasing an unused strip of land near Oak Ridge's entrance, in sight of the Lincoln Monument. There he built an outsized marker honoring himself as "Mr. Accordion." It caused a public outcry to which Bertelli, and the Oak Ridge board, were deaf. Shortly before his death in 2003, Bertelli posed with his beloved accordions and monument. A far more conventional but grander monument is the Staab family's overtly religious display (below), built in the early 1990s.

Five

PEOPLE AND ACTIVITIES

For a city of the dead, Oak Ridge is a pretty lively place. Workers patrol the grounds, keeping the landscape in order, tending grave sites, and making repairs. Employees occupy the office, and family and friends visit graves of loved ones every day. But many other activities regularly take place on the grounds. The large annual Boy Scout pilgrimage comes first to mind. Gov. Louis Lincoln Emmerson once compared the annual event with "nothing in the memory of man, except the pilgrimages to the Holy Land." But Oak Ridge's Civil War regiment reenactment ceremonies, historic tours, annual cemetery walk, and, of course Lincoln Tomb visits are all for the living population. And many people come to Oak Ridge just to enjoy the quiet beauty of the landscape, just as visitors did a century and more ago. In years past the superintendent and the Lincoln Tomb custodian have lived in houses on the grounds. Nature walks and photography shoots are not uncommon.

The remarkable beauty of Oak Ridge has been, and continues to be, the responsibility of hundreds of unseen hands past and present—administrators, groundskeepers, board members, volunteers, state employees, and others. Someone like former board president Dr. Henry Wohlgemuth stands out for his long-term, passionate commitment to beautifying and maintaining the grounds. But everyone associated with the cemetery seems to feel some part in its care. And that includes those in related occupations—funeral directors, florists, and even those involved with local tourism. Oak Ridge's success has been due to more than a century and a half of involvement by local citizens who appreciate its unique history.

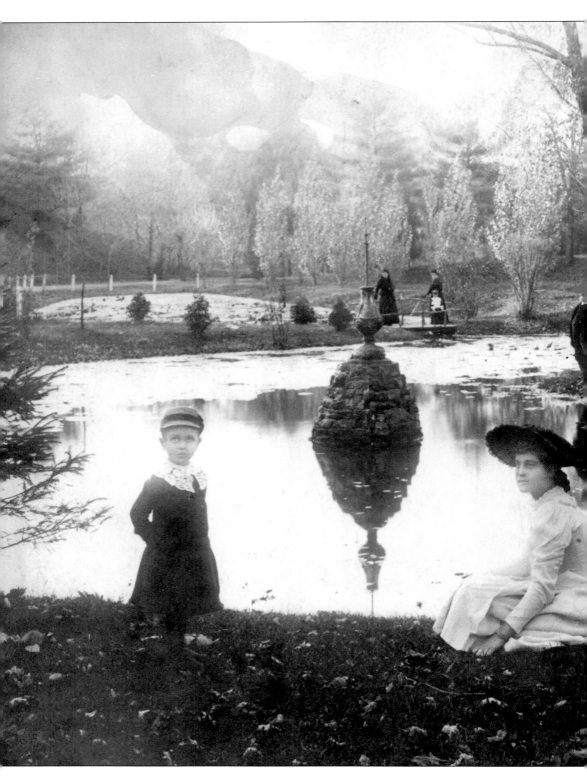

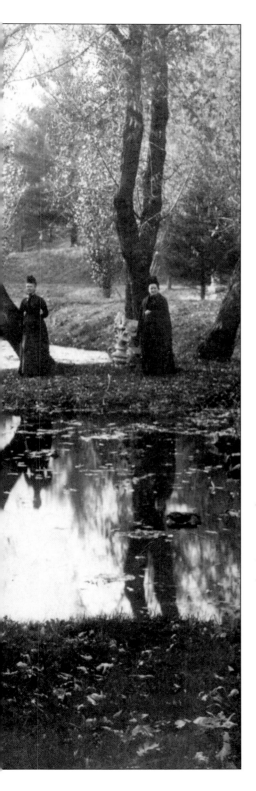

This evocative 1890s photograph, with its surreal, otherworldly quality, shows Oak Ridge superintendent Meredith "Med" Cooper (background) and family ranged round the Oak Ridge pond. In the foreground is daughter Annie Cooper, who later became Annie Ward. At far left, in front, is little Robert Watson Kuecher, dressed in cap and skirt. Landscape photography was then a serious hobby taken up by many people who began to self-consciously interpret their subjects in painterly ways, searching for beautiful or sublime backdrops, something Oak Ridge clearly offered. While there is no record of the photographer, there is information on what became of the little boy in the skirt. He grew up to become Bobby Watson, a minor character actor in Hollywood, whose greatest claim to fame was playing Adolf Hitler in several films, including *That Natzy Nuisance*, a slapstick comedy by Hal Roach.

Two men most responsible for Oak Ridge's physical appearance are George Willis (left) and Henry Wohlgemuth (below). Willis, the first sexton in the 1850s, had been employed at Long Island's celebrated Greenwood Cemetery, New York's first rural cemetery. Despite Oak Ridge board members' awareness of the new style and desire to re-create it here, they had a poor start with only the city engineer's grid street layout for the new cemetery. Willis brought experience and ideas for developing the site and may have suggested designer William Saunders. His obituary credited him for largely developing the plan. Wohlgemuth, a busy physician, gave countless hours of his time to guardianship of the cemetery until his 1905 death. As board president he directed printing of ordinances and cemetery history and carefully enforced landscape rules. During his tenure the Lincoln Tomb was built and reconstructed and permanent stone buildings erected.

The political appointment of Lincoln Tomb custodian is extremely secure. Only five men occupied the post between 1874 and 1976. The first, John Carroll Powers (right), was born on a Kentucky farm, but his mind seemed to "run more to writing, history and biography." In 1869, he began gathering stories of area pioneers, which he turned into the first history of Sangamon County, published in 1876. Powers helped Secret Service agents ambush criminals attempting to steal Lincoln's body and wrote a book about it. The "portly, fine looking old gentleman" died in office in 1894. Herbert Wells Fay, below, was called "a country newspaper man, with a country newspaperman's appreciation of what can be accomplished by advertising." Between 1921 and 1945 he ceaselessly promoted the tomb and Abraham Lincoln, even proposing the president's body be exhumed and displayed under glass.

George Cashman (above) was custodian from 1950 to 1976. Like the Powerses, Cashman and his wife, Dorothy, were a childless couple, who came to Springfield as adults and shared a deep interest in its history. Cashman penned historical articles and helped found the Capitol City Camera Club and Springfield Civil War Round Table. The Cashmans occupied the custodian's house amid a clutter of Lincolniana and other historical items. For several years Oak Ridge's superintendents also lived in the cemetery. Some, like Raymond J. Birnbaum (left), have been Springfield natives with previous connections to the cemetery. Birnbaum began working at the cemetery as a laborer in 1906. He proved valuable enough to be named assistant superintendent in 1911 and superintendent the following year. A widower at age 30, Birnbaum died in office at age 51 in 1939.

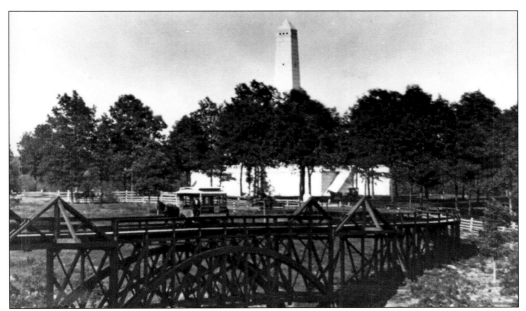

Oak Ridge Cemetery and the Springfield streetcar system are nearly contemporaries and it is doubtful if the cemetery would have proved popular without the new streetcars. Springfield's first horse- and mule-drawn cars appeared in 1861, the year following Oak Ridge's dedication. People could take the car to the cemetery and right to the Lincoln Tomb on a track and trestle bridge within the cemetery (above). This was later demolished, and the Fifth Street car line, shown below at Fifth and North Grand Avenue, took passengers to Oak Ridge (later renamed Lincoln) Park immediately east of the cemetery. Eventually visitors came by city buses and automobiles, but for a time the car with "Lincoln Monument" lettered on its side was the most popular way to get to Oak Ridge.

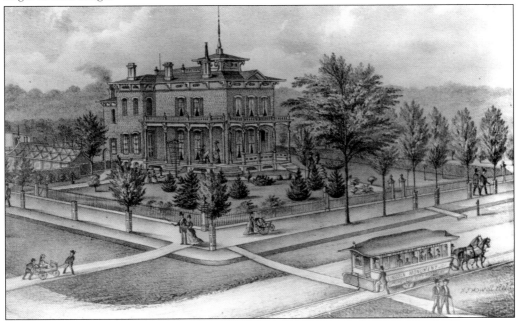

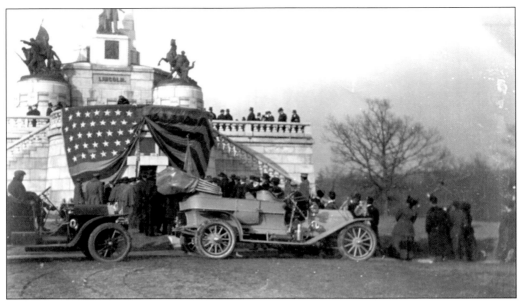

In the years after the Civil War, railroad travel became efficient, dependable, and comparatively inexpensive. Visitors to Springfield increased and businessmen, tourists, vacationers, evangelists, and celebrities, from Oscar Wilde to Queen Marie of Romania, set their feet down in Springfield. A good number of them made a stop at the Lincoln Tomb. Oak Ridge experienced a trickle that became a flood of visitors by the mid-20th century. Pres. William Howard Taft arrived by private railroad car on February 11, 1911, to speak to the Lincoln Centennial Association. He was escorted to the tomb in a Springfield automobile, made in the city (above). World War I hero Gen. John Pershing made a triumphant tour of American cities, including Springfield, and is seen at the tomb (below) surrounded by dignitaries and the public.

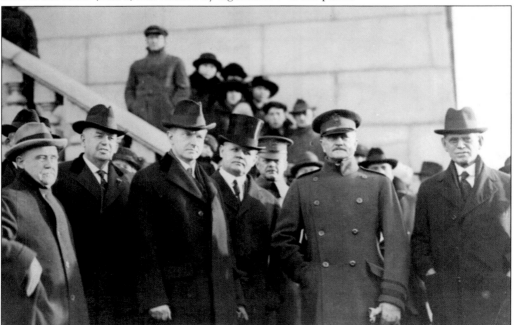

When the United States declared war on Germany in April 1917, England and France each organized groups of political leaders and officers as war commissions. These commissions toured the country. The French commission came to Oak Ridge on May 7, 1917 (above). Gov. Frank Lowden welcomed the gentlemen, including army officer Marshal Joseph Joffre, "the popular hero because of his defeat of the Germans at the battle of the Marne." Ex-premier Viviani was "the orator of the group," while Joffre "looks the staunch soldier that he is" and Jean Fabry, "the fighting 'Blue Devil of France,' stands airily on his wooden leg." Somewhere in back was the Marquis de Chambrun, relative of the Marquis de LaFayette. In the ominous, dark days just before World War II, a contingent of Polish military men visited the tomb (right). Poles soon proved brave American allies.

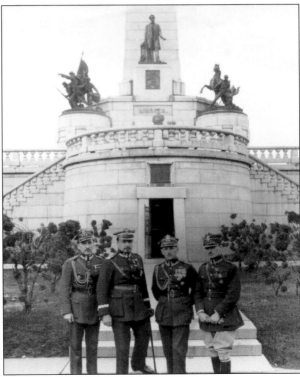

Entertainers were also drawn to Abraham Lincoln's tomb. When they played Springfield, many took a side trip to Oak Ridge and posed for publicity photographs, including Harry Lauder (left) and Joseph Rosenblatte (below). Phenomenally popular Scots comedian Lauder's "dialect" recordings included "I Love a Lassie." He was given a whirlwind tour, visiting Gov. Charles Deneen, Lincoln's home, a public reception, and "closing with a friendly visit to Springfield's exclusive gentlemen's club, The Sangamo." Afterward he paid "his respects to Springfield's most prominent and influential Scot, Col. James Robert Bruce Van Cleave" and daughter "Mrs. Dr. Blankmeyer." But it was in Oak Ridge where he paused for publicity photographs. Joseph Rosenblatte, a Jewish cantor, who visited in the 1920s, was not similarly welcomed by the most of the city's gentile organizations, which were, in the euphemism of the day, restricted.

The Lincoln Tomb remained popular with entertainers as their medium changed from vaudeville to live television. The photograph at right was taken by custodian George Cashman when comedian Danny Kay and members of a motion picture and television group visited in 1952. Television made piano-playing Liberace (below) into a superstar. Springfield funeral director Phil Bisch sponsored Liberace's Sunday night television program, which marked the start of a lifelong friendship between Bisch and the entertainer. Bisch "brought him to town so people could learn that the rumors about his personal habits weren't true . . . we asked him over to the funeral home and he fell in love with my Cadillac convertible." Bisch was the among the first guests in Liberace's new Sherman Oaks, California, home—"the one with the piano-shaped pool." During his 1954 visit Liberace poses with a funereal floral arrangement.

Springfield poet Vachel Lindsay, above left, gained an international reputation and brought literary fame to his hometown. He often took guests to visit sites associated with Abraham Lincoln. He is shown about 1917, at the height of his career, with custodian Edward S. Johnson (center) and an unidentified friend at the tomb. Over 40 years after Pres. William Howard Taft arrived at the tomb by automobile, presidential candidate Dwight D. Eisenhower and wife, Mamie, came to the tomb and hometown of his opponent, Illinois Democratic governor Adlai E. Stevenson (left). Eisenhower declined Stevenson's offer of lunch at the executive mansion. (Left, courtesy of the State Journal-Register.)

Political leaders visiting the tomb included John F. Kennedy (above) and Willy Brandt (below). Kennedy was campaigning for president in Springfield and made the obligatory stop at Lincoln's tomb, accompanied by Mayor Lester Collins (pointing). Calm and affable, Kennedy later joked about winning Illinois "by the overwhelming margin of 8,000 voters." West Berlin mayor Willy Brandt was given star treatment when he appeared as a guest for the banquet commemorating the 150th anniversary of Lincoln's birth. Despite state department protocol suggesting he be seated far below ambassadors and other diplomats, Gov. William G. Stratton insisted Brandt sit next to him. Crowds eyed Willy's wife Rut Brandt, who "lived up to her advance billing as a beauty." Few missed the point of the platform banner, quoting Lincoln's "A House Divided Against Itself Cannot Stand," as a reference to an East and West Berlin.

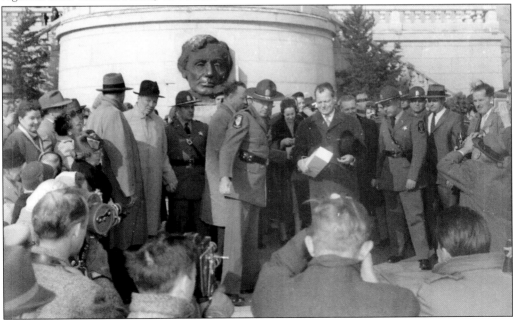

U.S. politicos are no more immune to wanting good luck than the average person. Rubbing Abraham Lincoln's nose for good luck is an old tradition at Oak Ridge. Seen at left, Richard Nixon (second from left) was in Springfield in 1964 stumping for Illinois Republican gubernatorial candidate Charles Percy (far left). Percy lost to incumbent Otto Kerner, but Nixon's efforts brought him favorable attention in the Republican Party and he was elected president in 1968 and 1972. Vice President Dan Quayle also rubbed the nose when he came to Springfield in 1989. Quayle appeared before the Sangamon County Republican Central Committee's annual Lincoln Day luncheon where he "got his heaviest applause when he recalled [President George H. W.] Bush's pledge not to raise taxes." Republican and Democratic politicians continue to visit Lincoln's tomb for publicity and, maybe, good luck.

Ordinary citizens enjoy Oak Ridge's beauty as much or more than visiting dignitaries, entertainers, and politicians. A century after it opened people continued to bask in its parklike setting. And more and more of these cemetery visitors came by automobile. The cemetery board's 1951 regulations (right) recognized the automobile's growing presence. The booklet cautioned that "the management reserves the right to compel all persons coming into the Cemetery or leaving the Cemetery to bring their machines [automobiles] to a full stop at the entrance." The unidentified man and boy (below) pose next to a sleek, black Pontiac automobile in the 1940s, with the Tanner Mausoleum in the background. The automobile, with its low chassis built for speed, rests quietly in this forested backdrop.

Regulations and Rules

OAK RIDGE CEMETERY

That beauty may be
and abide here now
and forever . . .

TELEPHONE 2-5573 .oOo. 1441 MONUMENT AVE.
SPRINGFIELD . . . ILLINOIS

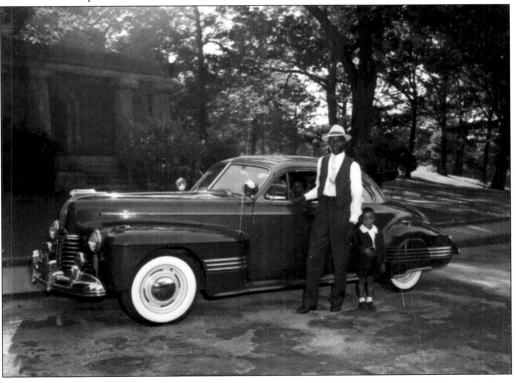

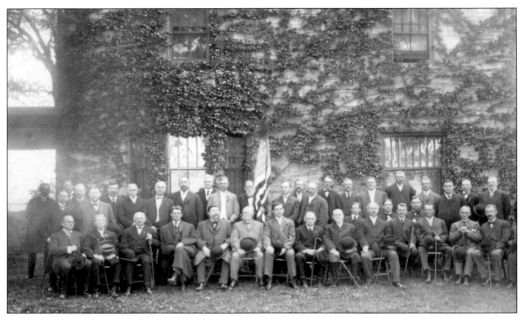

Activities of patriotic organizations have long been associated with Oak Ridge. The GAR was among the first. Founded in Springfield in 1866, the GAR was a fraternal society for Union veterans of the Civil War. At its peak it numbered more than 400,000 members across the country. It was also a powerful Republican political organization and counted five presidents among its membership. GAR conventions or "national encampments," with festivities, processions, and thousands of visitors, were eagerly sought out by U.S. cities, including Springfield. The practice of decorating veterans' graves by GAR members led to the founding of Memorial Day. Above, a GAR group poses outside the Lincoln Tomb custodian's residence in 1907. Below, the GAR mound at Oak Ridge serves as backdrop to a Memorial Day activity in 1980. (Below, courtesy of the State Journal-Register.)

Abraham Lincoln's February birthday anniversary has often been celebrated at Oak Ridge with a short speech and activities by patriotic groups. Members of the American Legion march toward the tomb in February 1964 (right). The memory of the Civil War lives on at Oak Ridge every summer when a group of men bring the 114th Illinois Civil War Regiment to life (below). The original 114th was organized at Springfield's Camp Butler in 1862 and reactivated in 1969. The group conducts a weekly retreat in period uniforms, with drum and bugle music, firing of replica rifles, and lowering of the tomb's flag. The flag is given to one of the hundreds of families who attend the ceremonies. Their focus on accuracy led some members to be cast in battle scenes for a television miniseries and Hollywood movie.

For generations Boy Scouts have made an annual pilgrimage to the tomb of Abraham Lincoln, with hundreds of thousands of Scouts participating in the April program through the years. A Saturday march from New Salem to Springfield commemorates the route Lincoln took to borrow and return books when he was studying law. The march, originally proposed to give Scouts an appreciation for Lincoln's commitment, has been expanded in recent years to add "an understanding of environmental stewardship." On Sunday the Scouts gather at the Lincoln Tomb for a wreath-laying ceremony. At its height in the 1960s, as many as 10,000 Scouts from across the country would attend. It remains the "largest annual scouting weekend next to the National Jamboree." Crowds gather to hear event speakers (above) in the 1950s. Below, Scouts salute during a 1980s march program. (Below, courtesy of the State Journal-Register.)

There are always plenty of flags and patriotic speeches at the annual Scout march, as seen in these two photographs from the 1960s. Scouts are also encouraged to follow any of three trails in the cemetery where they can practice trail skills, including compass reading. By the early 21st century, technology aided the events, with organizers using cellular telephones to report marchers' progress. When poor cell tower coverage interrupted reporting, the Sangamon Valley Amateur Radio group helped out with "ham" radio broadcasting along the way. The Illinois Environmental Protection Agency added its sponsorship in the 1990s, getting scouts to pick up trash along the march route. While originally limited to Boy Scouts, recent programs have included "Tigers, Cubs, Brownies, Girl Scouts, Boy Scouts, Explorers, Venturers, and adult scouts."

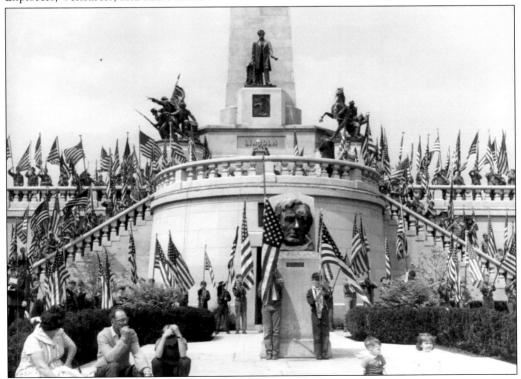

For several years some of Oak Ridge's permanent residents have lived again through local actors. Beginning in 1996, on a beautiful Sunday in October, visitors met people from every walk of life in Springfield's past. Sangamon County Historical Society members and other volunteers researched and scripted these portrayals. Crowds on the 2000 tour were transported to the grave sites (above) and afterward learned more about the cemetery's history. Below, Linda Schneider, as Emma Willett, shares her story of coming here as a bride from New York City in 1863 and of her husband Samuel's rise to prominence as a merchant tailor. "He does nothing but a high grade of tailoring business, believing that anything which is worth doing at all is worth doing well." The shop interior, reflecting Mr. Willett's artistic taste, was referred to as an "art palace."

Above, guests crowd around interpreters to hear stories of Springfield past. The walk also gave visitors a new appreciation for Oak Ridge and its development. Below, Deb Herndon launches forth as the stylish Clara Irwin, wife of Abraham Lincoln's banker, Robert Irwin. Clara Irwin took great pride in her fashionable clothes and enjoyed her high position in Springfield society. Born in Philadelphia, Clara Doyle married Robert Irwin in St. Louis and came with her husband to Springfield in January 1834. On that journey the Irwins crossed the frozen Mississippi River, "having to jump the open space between the moving ice and the shore." At her death in 1884 she was listed as being of "the advanced age of 69 years."

At left, Gov. William Bissell (Bill Herndon), recounts his colorful life of escaping a steamboat wreck, becoming a physician, marrying and being widowed before age 35, taking a law degree, serving in the Mexican War, remarrying, and entering politics. As a U.S. congressman he found southern congressmen "insolent, overbearing, and bullying beyond all belief." He accepted a challenge to a duel with Jefferson Davis. He became a Republican because of the Democrats' stand on slavery. He was Illinois' first Republican and first Catholic governor. His frailty from illness was variously called arthritis, neuralgia, or a war injury, but his doctor confirmed it was syphilis, and he died of its effects in 1860—the official cause listed as pneumonia. Below, Lisa Sabo recounts the comfortable life of Anna Johnson, wife of a prosperous Springfield soda water manufacturer.

At right, Prof. Frederick Feitshans (Paul Cary) was a Latin scholar, teacher of mathematics and Greek, and leading city educator whose one purpose in life "was to secure, if possible, to every child in this city, an excellent education. He refused many chances to accept work elsewhere, although the positions were more lucrative and esteemed, more desirable and honorable." For this he sacrificed his health and died at age 40 in 1886. John Brewer (below), in the person of Don Schneider, was sexton for the old Springfield cemetery, which preceded Oak Ridge. The Tennessee native was appointed to his position seven times beginning in 1839 and ending in 1852, when he was jailed for shooting a man. Later he sued his wife for divorce and was himself fined for drunkenness and disturbing the peace, before dying at age 53 in 1871.

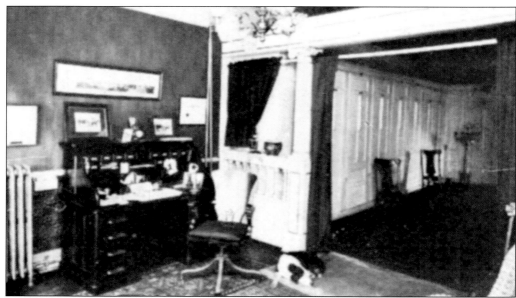

Some Oak Ridge functions take place beyond the cemetery grounds. Funeral customs changed over the years. Funerals at home were increasingly replaced by those provided by commercial funeral homes. First called "funeral parlors," most were housed in commercial buildings. Typical was C. T. Branson's operation (above) at 330 South Sixth Street, shown in about 1912. Branson made the atmosphere homelike—even down to the family dog napping at the foot of the desk chair. Funeral directors also provided conveyance to the cemetery. They were also among the first to offer ambulance service. E. H. Wallace (below) proudly displays his elaborate hearse about 1915. Wallace was a licensed embalmer and had a "lady attendant" on duty at his 119 North Eighth Street firm.

Despite efforts to make downtown funeral parlors homelike, many still had an officelike feeling. Newer firms began to use large private homes in residential areas, which offered families comfort and privacy. O'Donnell and Staab Funeral Home, 1227 South Seventh Street, seen above about 1929, was typical of these. As late as the 1990s, Staab Funeral Home touted its "comfortable, home-like atmosphere." Supplying funeral arrangements kept Springfield florists busy from the 19th century on. With the coming of glass-roofed greenhouses in the 1850s, hothouse flowers were now available year-round. For over a century a floral shop at First and Elliott Streets was Oak Ridge's closest greenhouse. Wirth and Gaupp Florists eventually became Hennessey's and operated at this site until the 1990s. Below, David and Isabelle Wirth pose with their two young daughters around 1905.

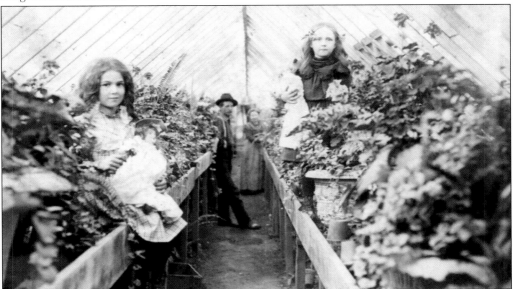

The informal Oak Ridge staff picnic in the 1980s (above) recalls a century earlier when visitors used Oak Ridge the way later generations used public parks. Although no Victorian-era group would have been as informal, the idyllic background was as much appreciated by people in the 1980s as in the 1880s. It takes a large crew to keep Oak Ridge well groomed and orderly. Two landscape crewmembers and their tractor (below) make a repair. Mechanical equipment replaced real horsepower in 1930. "Historic Oak Ridge," noted the *Illinois State Journal*, "is being invaded by the progress of more modern ideas. Mechanical horse power will replace the old fashioned power there," when a pair of horse teams were retired in favor of a tractor. (Courtesy of Oak Ridge Cemetery.)

Six

AMONG THE DISTINGUISHED

Death makes everyone equal, at least in theory. At Oak Ridge's dedication James Conkling paid service to this idea when he said, "The grave is the common inheritance of all mankind. The high and the low, the rich and the poor, the learned and the unlearned, the master and the serf, the monarch and his slave, the refined and the barbarous, are there reduced to the same level."

But, in reality, the living almost always distinguish the famous and favored and continue to honor them long after their deaths. Erecting expensive monuments, designed to impress, is one way the famous are memorialized. This explains the continued popularity of cemetery monuments despite critics decrying "obelisk after obelisk, stone posts and slabs of all shapes and sizes, and stone tombs," detracting from the landscape's natural beauty. The size of their monuments, however, does not always reflect people's status in life, or changes in their reputation after death. Illinois governor John Tanner, not much known beyond his home state, has a grand mausoleum, while internationally known poet Vachel Lindsay's grave is marked by a simple, chaste stone, distinguished in its modesty.

Abraham Lincoln is, of course, the most famous American buried at Oak Ridge. But there are many others, some rich, some not, commemorated for accomplishments in their lives or, sometimes, for their tragic part in the larger history. Among the latter is William Donnegan, lynched in Springfield's infamous riot of 1908. Oak Ridge hosts a president, Revolutionary War veteran, Illinois governors, statesmen, scoundrels, pioneers, infants, industrialists, teachers, poets, thieves, and labor leaders. Said one writer, "the scores of Springfield and central Illinois people who make daily pilgrimages to the resting places of loved ones bear mute testimony that thousands of those responsible for this city's greatness also are interred in the famed cemetery." A handful of those, once known beyond their city, are profiled on the following pages.

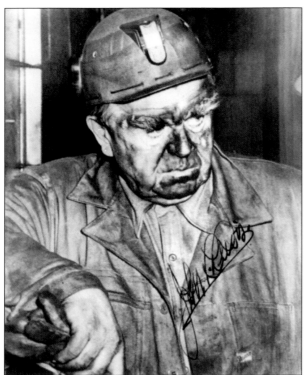

John L. Lewis (left), "a colossus of American labor, an eloquent spokesman for working people," was president of the United Mine Workers for 40 years. Lewis stood up to businessmen and presidents to achieve fair wages and one of the first employer-paid health and retirement systems. Bushy-eyebrowed Lewis was "one of the most admired, feared, effective, and colorful trade unionists in American history." Largely forgotten at his death in 1969, he was quietly buried at Oak Ridge. Post Cereal Company founder, C. W. Post, was born in Springfield and his parents are buried here. He recovered from three business failures and a nervous breakdown through Dr. Harvey Kellogg's famed sanitarium and vegetarian diet. Shortly afterward he developed a coffee substitute so successful he was spending $1 million annually advertising it. His Springfield implement firm is shown below.

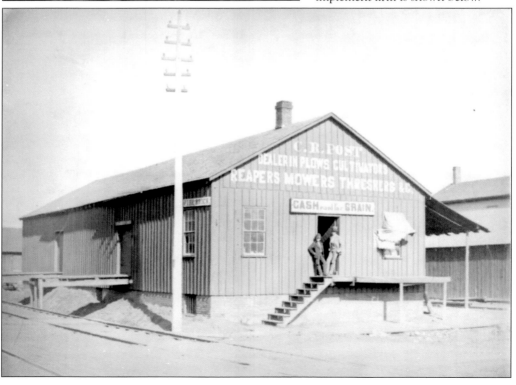

William H. (Billy) Herndon was Abraham Lincoln's third and last law partner. Many were surprised when Lincoln picked the young, inexperienced junior partner. Herndon, an ardent abolitionist, broke with his proslavery father. Lincoln's cool public persona contrasted with Herndon's "emotional and self-absorbed" personality. But Herndon was also a "strong Republican." He coauthored an early biography of Lincoln that angered Mary Todd Lincoln and her children. He died in modest circumstances and was buried in Oak Ridge in 1891. Far more circumspect than William H. Herndon was Shelby Cullom, described as "Mr. Republican" for his long political career. He came to Springfield in 1853, studied law, and was appointed city attorney. He was elected Illinois congressman, governor of Illinois, and United States senator, serving with distinction until 1913, the year before his death.

THE EDWARDS MONUMENT.

This Italian marble obelisk (left) marks the Edwards family lot at Oak Ridge. Illinois territorial governor Ninian Edwards and his son Ninian W. and wife (Mary Lincoln's sister Elizabeth,) are buried here. Also on this lot is Edward Lewis Baker (below), who married Ninian W. and Elizabeth's daughter Julia. Baker was a Harvard Law School graduate and part owner and editor of the *Illinois State Journal* newspaper. It was Baker, and a handful of political allies and friends, who spent the day celebrating with Abraham Lincoln when he received news of his successful nomination as Republican presidential candidate. Baker personally delivered the news to Lincoln. Baker's last 20 years were spent in Buenos Aires as American counsel to the Argentine Republic.

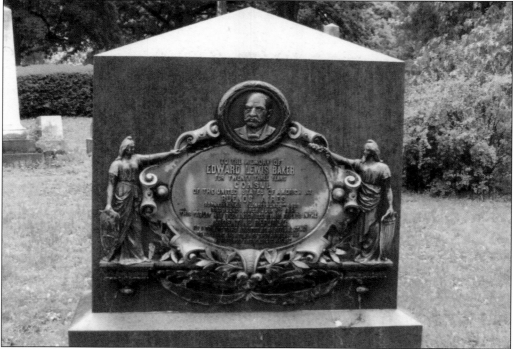

Kentucky-born William Donnegan (right) came to Springfield and worked as a shoemaker in the 1850s. Abraham Lincoln was a customer. He helped countless African Americans escape slavery through the Underground Railroad and made a small fortune bringing free blacks to Springfield for work. By the early 1900s, Donnegan had acquired a fair amount of Springfield real estate and was living with his white wife, Sarah. He had publicly recounted his part in the Underground Railroad and recently purchased a lot in the newly opened, all-white Hawthorne Place subdivision. These things may have contributed to white resentment and made him a target of violence during the 1908 Springfield race riot. He was dragged from his home at Spring and Edwards Streets and lynched. His grave (below) was unmarked until 1995, when the riot history was reclaimed by Springfieldians.

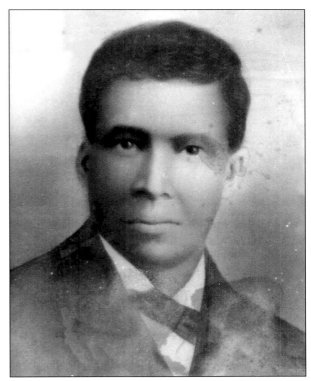

Ulysses S. Grant's daughter, Nellie, is buried in Oak Ridge Cemetery. Although her famous father had lived in Springfield during the Civil War, Nellie did not. She was married to an Englishman, Algernon Sartoris, in a White House ceremony. The couple lived in England until his death in 1894. When Nellie Sartoris returned to the United States, she met and married Frank Hatch Jones of Chicago. At their deaths the couple were buried in Springfield, near Jones's first wife, Sarah Bunn Jones (above). Albert Ide (left) was a Springfield industrialist, foundry owner, and the city's first steamfitter. In 1880, he visited Thomas Edison, who was unable to promote electricity generally because he lacked a regulated engine that kept lights steady rather than flickering. Ide perfected his Ideal engine for that purpose, making a large fortune in the process.

Abraham Lincoln studied law under John Todd Stuart (right) and became his first partner in 1837. Stuart was a favorite cousin of Mary Todd Lincoln and was welcomed at the White House, despite holding strong anti-emancipation beliefs. His firm, Stuart, Edwards, and Brown, continues today as Brown, Hay and Stephens, Springfield's oldest law office. Thomas Rees (below) was publisher of Springfield's *Illinois State Register* from 1881 until his death in 1933. Between 1910 and 1920, he and his wife traveled extensively. In Belgium and Holland Rees became passionately interested in carillons and bell playing. He left $200,000 to the Springfield Park District for a carillon and tower, which were dedicated in June 1962.

THOMAS REES

THE McCLERNAND MONUMENT.

Gen. John A. McClernand served six terms in Congress, from which he resigned when Pres. Abraham Lincoln appointed him brigadier general of volunteers at the opening of the Civil War. He rose to major general and served in numerous battles. Elected circuit judge in 1870, McClernand presided over the 1876 Democratic National Convention. His monument (left) marks his death at age 90 in 1900. Bachelor Abraham Lincoln boarded with the Butler family when he came to Springfield, and William Butler was a staunch friend until the two quarreled and stopped speaking. They later reconciled. Butler became Illinois treasurer during the Civil War when the city's new prisoner of war camp—and later national cemetery—Camp Butler (below) was named for him. Butler is likely the only person in Oak Ridge to have a cemetery named in his honor.

People have passed through the entrance of Oak Ridge Cemetery for 150 years—not just mourners seeking solace but visitors to Abraham Lincoln's monument and others just to enjoy the beauty of the landscape. Each finds a quiet, peaceful place, apart from daily life. Oak Ridge founders trusted that this silent grove would long be a place for the living, offering inspiration through its natural and man-made landscape. There is much to learn from places like Oak Ridge and its monuments. According to a 1902 Oak Ridge history, monuments can "teach us lessons." They "serve to perpetuate the recollection of kindly sympathies and tender affections, as well as deeds of valor, and the records of human greatness." Oak Ridge has become so much more than a cemetery. It has become a national treasure. Through every season in nature and life Oak Ridge Cemetery continues to charm the eye and sooth the mind of visitors. (Courtesy of the State Journal-Register.)

INDEX

DISCOVER THOUSANDS OF LOCAL HISTORY BOOKS
FEATURING MILLIONS OF VINTAGE IMAGES

Arcadia Publishing, the leading local history publisher in the United States, is committed to making history accessible and meaningful through publishing books that celebrate and preserve the heritage of America's people and places.

Find more books like this at
www.arcadiapublishing.com

Search for your hometown history, your old stomping grounds, and even your favorite sports team.